HOW TO SELL
YOUR ART ONLINE

HOW TO SELL
YOUR ART ONLINE

LIVE A SUCCESSFUL CREATIVE LIFE
ON YOUR OWN TERMS

CORY HUFF

ILLUSTRATIONS BY CYNTHIA MORRIS

HARPER DESIGN
An Imprint of HarperCollins Publishers
www.hc.com

HarperCollins books may be purchased for educational, business, or sales promotional use. For information please e-mail the Special Markets Department at SPsales@harpercollins.com.

Published in 2016 by
Harper Design
An Imprint of HarperCollins*Publishers*
195 Broadway
New York, NY 10007
Tel: (212) 207-7000
Fax: (855) 746-6023
harperdesign@harpercollins.com
www.hc.com

Distributed throughout the world by
HarperCollins*Publishers*
195 Broadway
New York, NY 10007

ISBN 978-0-06-241495-3

Library of Congress Control Number: 2015957169

Printed in Malaysia
Fifth Printing, 2020

CONTENTS

THE CREATION OF THE STARVING ARTIST MYTH

In January 1861, Henri Murger lay coughing out the last of his life. In his short thirty-nine years, he had managed to become an influential writer, but had lost all of his wealth. A friend sent money to help pay his medical expenses, but it wasn't enough and Murger was near death's door.

One can imagine Murger reflecting back on his life and the way that he had managed to popularize Bohemian culture. His popular book *Scènes de la vie de bohème* told the story of the Bohemians in such a way that he made their poor lifestyle seem somehow better than the lives of the nobles in Paris. The Bohemians in Murger's book were prototypes of the starving artist—writers, painters, and other creatives who eschewed material wealth in favor of creating art without commerce.

Murger's book, originally a collection of short stories, inspired Theodore Barriere to write a play with Murger

called *La Vie de la Bohème*, which played to great success at the Théâtre des Variétés. This play later inspired Puccini's classic opera *La Bohème*, which in turn inspired many other works, including the megahit musical *Rent* (both stage and film adaptations).

The Bohemians were not the only group to pursue literary and artistic endeavors while living in financially poor circumstances. Subcultures similar to the Bohemians exist in written record as far back as Alexandria and Rome.

These subcultures were rarely celebrated. They were seen as dirty, second-class citizens by the mainstream and even viewed themselves that way. The sons and daughters of peasants, they moved into the cities to obtain work, but were confronted by the cold reality that there were not enough jobs for them. These Bohemians were starving artists not so much out of a desire to rebel against the culture but rather because France's economy had not yet expanded enough to give them good jobs, or any jobs.

Murger was one of these people. He was the son of tailor. He toiled at odd jobs but didn't have the talent to be an artist,

The Birth of the Starving Artist Myth

in Paris, of course.

HISTOIRE DE PARIS

Henri Muger, a French writer, published a book called Scènes de la Vie Bohème. He recounted the struggles of the artist to survive. The bourgeoisie found this romantic and made entertainment of observing and emulating artists' lives.

so he turned to writing. In his writing, he romanticized the life he and his friends lived. It was the advent of Murger's *Scènes* that raised the Bohemians from their place of cultural obscurity to an icon of cultural relevance and aspiration.

When *Scènes* became popular, people flocked from all around Paris to visit the Bohemian parts of the city. They took over the cafes, wandered through the streets gawking like they were at a zoo, and even went so far as to create fashions after the Bohemian look—ironically born more of necessity than a desire to look great or make a statement.

But Murger had expressed that this Bohemian life was a means to an end, a temporary way to live while figuring out how to bring in more money. People who were unable to lift themselves out of this life of poverty would destroy themselves. This is exactly what happened to Murger. His final words were, "No more music! No more alarums! No more Bohemia!"

If Murger himself, an early teller of the stories of the starving artist, wished that people understood this was not a lifestyle to emulate, then why has modern culture so thoroughly embraced it?

The answer comes with the understanding of how myths are made.

Some ideas become so prevalent, so popular, that they take on a life of their own. They start out as a simple story, told by a good storyteller, and grow. With each telling, the less interesting parts are taken out, while the more interesting, salacious, and compelling parts are embellished. As more and more people tell the story, people start to believe the story is true.

The Bohemian story is a myth, one people rely on to explain the artist mindset. The Bohemians were untrained artists who were not compensated for their art. In Murger's telling, these artists were better than mere mortals. They were like Greek heroes: "In ancient Greece, to go no further back in the genealogy, there existed a celebrated Bohemian, who

lived from hand to mouth round the fertile country of Ionia, eating the bread of charity, and halting in the evening to tune beside some hospitable hearth the harmonious lyre that had sung the loves of Helen the fall of Troy."

Not only does Murger transform the Bohemian from an ethnic group to a class of artists, but he transforms these artists into a class that includes Raphael, Michelangelo, Molière, and Shakespeare, and makes them equal to the kings of France, the saints of Catholicism, and gods. He sets up the reader to believe that Bohemia, the state of being a young, poor artist, is a desirable and noble state of being while also admitting that Bohemia is, and should be, a temporary state: "Bohemia is a stage in artistic life; it is the preface of the Academy, the Hotel Dieu, or the Morgue." In other words, it's okay to be a poor, struggling artist. Enjoy that time, but move on and become a professional, or face the reality of poverty: sickness and death.

Despite Murger's warnings, many artists throughout history have embraced the starving artist mindset, choosing to suffer for their art. Society has a habit of rewarding the greatest of these artists postmortem.

Mozart was a successful composer during his life. The popular legend is that the rival composer, Salieri, helped keep Mozart down by interfering in his life and preventing him from achieving key positions. While it is certainly true that Mozart and Salieri competed for several of the same positions and opportunities, there is no evidence that Salieri used his influence to harm Mozart. The two even created a handful of works together.

What is true is that some of Mozart's choices contributed to his poverty. Early in his career, he left a permanent position as a court composer in Salzburg in search of something he would enjoy more. Over the course of the next few years, Mozart turned down several well-paid opportuni-

ties. After receiving a position with Bishop Colloredo in Vienna, Mozart made his presence so painful that the bishop's steward dismissed him with a literal "boot to the arse." Even after his freelance career began to take off, Mozart hamstrung his fledgling family by spending more than he was bringing in. His lavish lifestyle included a large apartment in Vienna, the most expensive instruments, and high-end private schools for his son.

None of this is to condemn Mozart; rather, it shows that while popular myth says that artists are by their nature poor, it is certainly true that a hardworking, talented artist can make a living with their art—if they are smart about how they do it. Mozart took risks, made enemies, and made poor financial decisions. I have little doubt that if Mozart had been a little more conservative with his money, he would have lived longer and created even more great work.

Vincent van Gogh was an exceptionally talented painter, even as a young artist, to the point that the art dealer Goupil & Cie hired him as a twenty-year-old, paid him a handsome salary, and put him up in a flat in London and then Paris. Van Gogh, however, didn't like the commercial side of art and let collectors know it, causing his dismissal after just a few years.

After his dismissal by Goupil & Cie, Van Gogh chose to live a life of poverty as a minister to a small mining village. Signs of his mental illness began to manifest. He failed the ministry exam, moved in with a prostitute, burned his hand in a fit of protest over his love not being reciprocated, was accused of rape, and famously cut off his own ear. He was remembered as "dirty, badly dressed and disagreeable," and "very ugly, ungracious, impolite, sick" by Jeanne Calment, a girl who sold him colored pencils.

Late in his life Van Gogh committed himself to a mental institution.

When he emerged, he lived in a seventy-five-square-foot room for the short remainder of his life, which ended with him shooting himself in the chest and dying from the infection.

After his death, Van Gogh was lionized by the Dutch community of painters and by the world at large. While his work was undeniably brilliant, the adulation of his art has caused some to forget that he lived a miserable life due to mental illness. While studying his technique is useful, his life is more of a cautionary tale of the problems at the intersection of creativity and mental illness.

By contrast, there are also legendary artists who became wealthy through a combination of their talent, their choices, and some good luck.

Pablo Picasso started his career inauspiciously. The son of a middle-class art professor, Picasso initially moved to Paris and shared an apartment with Max Jacob, a journalist and poet. They were too poor to afford a larger place, so Picasso slept there during the day and worked at night, while Jacob worked during the day and slept there at night.

Picasso became friends not only with many of the most important artists in Paris, but also with wealthy collectors and gallerists like Gertrude Stein and Daniel-Henry Kahnweiler. Stein purchased many of Picasso's works, helping to lift him out of poverty, and Kahnweiler helped establish Picasso as a major artist, making both of them wealthy. Picasso's relationship with Kahnweiler would last many years. While their relationship included conflict, Picasso was smart enough to recognize where his money came from, and he continued to nurture the relationship and didn't throw it away.

El Greco reinvented his style when he moved from Crete to Venice so that he would be distinguished from other painters. He eventually became a highly sought-after and wealthy painter, employing assistants and receiving commissions from royalty and wealthy persons. Matisse

and Duchamp were also well off during their lifetimes. Throughout history, there have been many artists who were well off financially.

How did they do it?

For the most part, it boiled down to a couple of things: they were able to get along well enough with a successful art dealer, noble, or gallerist; and they had enough presence of mind to save their money instead of spending it all.

The problem, and this is the crux of what this book is about, is that unless an art-

ist was lucky enough to meet and befriend a wealthy gatekeeper, they usually lived their lives in poverty, or perhaps, if they were lucky, they had a moderate middle-class income. Being an artist has always meant depending on just a few wealthy individuals. In the business world, this would be seen as a serious problem. You never want your business to be vulnerable to the whims of just one or two customers.

The gallery owner is protected from this scenario by having a large list of potential collector clients. If one of those collector clients goes away, there are others to replace them; so even if a gallerist loses their wealthiest collector, they can still make some money. But for artists, if they were lucky enough to get into a gallery in the first place, their entire

financial situation has been dependent on just one person—the gallery owner. A lucky handful of artists might be in a position to have their works displayed in more than one gallery—but this is usually a very tiny percentage of artists.

Art world gatekeepers have been in control of who makes money from art for hundreds of years. This is no different from many other businesses, from banking to food to music. Times change, however, and the model of profit by controlling supply is becoming more and more difficult. The Internet has made information and communication much easier, and the fine art world is starting to see the effects of a loosening in ancient structures.

Before I dive too deeply into how these changes have affected the art world, let's look at a related industry: music.

In 1999, Napster emerged as one of the first big-money, high-profile, peer-to-peer, file-sharing websites. If someone wanted to share their computer's library of music files, Napster made it easy by bringing together music enthusiasts from all over the world. While Napster was not the first site to do this, it quickly grew and became the most high-profile, peer-to-peer sharing site.

At the time, the music industry was controlled by just a handful of very large gatekeeper corporations. They saw Napster as a threat. To them, peer-to-peer sharing was stealing. They were caught flat-footed by the Internet, and Napster became the symbol of the threat the Internet posed to their industry. Big name musicians like Metallica joined with their labels to sue Napster and drive it out of business. The music labels aggressively pursued anyone who they suspected of file sharing, leading to embarrassing situations like suing an eighty-three-year-old woman who refused to own a computer—and who had passed away before the suit was filed.

Conversely, some musicians benefitted tremendously from file sharing. Radiohead was a successful band from the United Kingdom whose music had never hit the top 20 in the United States. Their album *Kid A* was leaked to the Web and downloaded millions of times. The recording industry made a big fuss about how this would kill album sales, yet when the album officially premiered, it immediately went to number one on the Billboard 200. Since the album had received little radio play, file sharing was seen as at least partially responsible for the success of *Kid A*. Since then it has become widely acknowledged that file sharing is a reliable way for unknown artists to cultivate a following.

Radiohead became a pioneer in direct-to-fan downloads. In 2007 the band released their album *In Rainbows* through their own website as a digital download. They offered fans the ability to pay whatever they thought was appropriate, including nothing at all. They ended up selling 1.2 million downloads the day of release, with only ten days notice. Ed O'Brien, a guitarist in the band, later told Stephen Colbert that "we sell less records, but we make more money." This is because by selling directly to fans instead of using their record label, which would take a cut of the proceeds, Radiohead got to keep a larger portion of the profits.

This titanic shift for a band as famous as Radiohead precipitated a number of bands to leave their record labels and go independent. The popular band OK Go advocated against record labels using software to prevent copying of music, or preventing fans from embedding their music videos. The band had become popular in 2002 on the back of a viral music video for the song "A Million Ways," but their label, EMI, had become too controlling about how the band's new videos were shared. OK Go ended up leaving EMI to form its own record label.

But it's not just famous bands that benefitted from the shift in digital music.

Independent musician Amanda Palmer rose to prominence on the back of file sharing and fierce live performances. After years of going it alone she got a record deal. No stranger to controversy, Palmer fought with the label Roadrunner Records after they tried to cut shots of Palmer's stomach from a music video for her song "Leeds United." She claimed the label told her she "looked fat." After a protracted struggle, Palmer got the label to release her. Palmer went on to raise over $1 million in a crowd-funded campaign to record a new album. Palmer's outspokenness on the decline of corporate music labels is well documented on her personal blog. She has become a beacon for artists seeking independent success and control of artistic expression. There are now hundreds of musicians doing it the way Palmer has done it.

I believe the music industry is a model for what is beginning to happen in the fine art world. Starting in 2008 with the financial crisis in the United States, many midtier art galleries closed due to financial difficulties. Collectors are beginning to become interested in connecting with artists directly, and many artists are becoming increasingly interested in cultivating their own collectors.

Hazel Dooney is a great example. In 2001 Hazel made a splash when she was invited to participate, with several other Australian artists, in a documentary about a journey to central Australia. Hazel went on to have her work shown at several prestigious galleries in Australia. After several negative experiences with gallery dealers, Hazel reported that she would no longer show in galleries. She accused several gallery dealers of being sexist and claimed she would be better off as an independent artist. In a 2011 TEDx Australia talk, Hazel excoriated gallery dealers. She took them to task for wanting to put up a barrier between her and collectors, for treating her like a weak little girl who couldn't handle the rigors of business, and for taking 50 percent of the revenue. Hazel goes on to

talk about how she embraced Internet ideals of exchange—that information wants to be free; that attention equals currency; that ubiquity, not rarity, defines value; and that a truly networked society had to be open and unrestricted.

Hazel also goes on to point out that artists like Andy Warhol already understood this idea of the open exchange of ideas and ubiquity. After all, Warhol coined that phrase "fifteen minutes of fame." Warhol mass-produced his art and appropriated popular images, leveraging the attention of the art world into multiple revenue streams and increasing the value of his individual pieces.

Of new gallery dealers, Hazel says they are "just as blinkered. It's as if the Internet never happened. It's as if they're clinging to denial while their whole fucking world is torn away from them in radical and irreversible change."

Hazel's work sells for tens of thousands of dollars at auction houses like Christie's and in the private market. She has been featured in major magazines like *Vogue Australia* and *Wired*.

While there's no one quite like Hazel, there are many other examples of artists who have embraced the independent lifestyle and made a successful living selling art on their own, often without galleries, using the Web as a key component of their business. In the rest of this book we will examine models of abundance and scarcity, how art business models work, how to connect with collectors and fans directly, and we will share interviews and examples with successful artists from all over the world.

We will start with Gwenn Seemel, a painter currently living in Portland, Oregon. She is an artist who, without much help from galleries or traditional art world contacts, has made a living from her art for over ten years.

Gwenn has done this by building a strong relationship with collectors directly through blogging, social media, and e-mail.

Gwenn treats her art career like a business, and has acquired the necessary skills to do that.

She graduated from Willamette University with a BFA in painting. Initially, she received a few commissions from people she meet through her brother, and from there she began growing her contacts through those collectors into a larger list of interested fans.

Gwenn is passionate about the Web. "Fundamentally, an art career has always been about getting people to see your work," she says. She points out that on the Web, there are opportunities for people to talk about your work. There are more people with large platforms that can share your work with their audience.

Gwenn has benefitted from those platforms. She has a large following on Twitter and Facebook. Gwenn's early adoption of these Internet platforms made her visible to some niche blogs and websites with much larger followings. Gwenn's work has been featured on sites like ScientificAmerican.com, Hyperallergic.com, and BoingBoing.net, a pioneering blog with millions of readers.

But even more important than being featured on these other platforms, Gwenn has built up a powerful and popular blog at her website, GwennSeemel.com.

The Web has helped her make connections with collectors and become more comfortable with talking about her work. You can see this in her *Crime Against Nature* series of paintings. Gwenn writes openly on her blog about the fact that she suffers from endometriosis. In a March 2011 blog post, she shared a story about how she ended up in the hospital, having surgery to fix some of the damage. The disease eventually ended her ability to have children.

In 2012, Gwenn launched a crowd-funding campaign on Kickstarter .com to raise money for researching her next series, which became *Crime Against Nature*. From her website: "For all my investigating and exploring, I still couldn't control whether or not I can have children, but I could decide to have a children's book instead. So I did. Crime Against Nature is this book and it's also a series that I sometimes exhibit as a version of the text that viewers can wander through as they read. Whatever the format, book or show, Crime Against Nature is meant for the kid in all of us: the person who hasn't yet felt the pressure to conform, the one who still sees the infinite possibilities of being."

The series was a huge success and has been Gwenn's primary means of income since then, not only generating sales of the original paintings, but also generating book sales, print sales, and commissions for custom portraiture.

Gwenn's blog is not just a platform to talk about her art. It's a way for her to take a stand on other topics that she feels passionately about. She advocates for women who have endometriosis. She's a fierce critic of copyright law and refuses to copyright her own work. On the Uncopyright section of her website it says, "I am happy for you to copy, display, and use my work in any way, and you are welcome to create derivative works from my images, words, and videos. I would love it if you gave me credit when you use my art."

Through several blog posts, Gwenn points out the myriad instances of how copyright law is used by large corporations to bully people into doing what they want. According to Gwenn, copyright abuse is rampant, and she refuses to participate in it.

Perhaps more important, Gwenn feels that once she releases a piece of art into the world, there is more to gain from her work being shared and discussed, and copyright creates friction in that conversation.

Gwenn's stance on copyright has not hindered her opportunities. Despite the fact that her images are freely available on her website, she receives occasional licensing deals from major corporations like the Gap, which ran an ad featuring her work in September 2013.

Gwenn understands that making it as an artist is not a mystery. It's about having a mindset of success, understanding the basic principles of business, and taking daily action toward your goals. The artist who does these things consistently over time has a great chance at becoming a financially viable artist.

HOW SUCCESSFUL ARTISTS THINK

As a man thinketh in his heart, so is he.
—James Allen, *As a Man Thinketh*

Many young artists talk about not selling out. They want to make art for the sake of art, without commercial interests. Sometimes they idolize artists like Mozart or Van Gogh and see how our culture lionizes them. They want that same acceptance and recognition.

The artist who is deep into the mindset of the starving artist thinks that this kind of life is what's expected. They hear stories of famous artists that took drugs and think that if they model that artist's behavior, they will have that artist's success. They don't understand that these things have nothing to do with being an artist.

Another phenomenon is the culture created by young artists just out of art school who think that their artistic training and calling makes them somehow more special than people who are not trained artists. To those artists, I share this quote by William Grant Turnbull: "You have a unique and amazing contribution to make to the world. Your job is to find both what it is and who needs it. Otherwise, you just have a really cool hobby and should probably just enjoy it on your own time and go marry into money."

Your mindset is a vital element of your success. It's just as important as business skills.

On my website, I give away a free ten-part course on how to get started selling art online. Whenever someone signs up for my mailing list, they get an e-mail from me asking what their primary struggle is with selling art so that I can point them to information that is immediately helpful.

One of the most common responses is fear.

Many artists suffer from a fear that their art isn't good enough to sell, or that they won't be able to sell enough of their art to make a living—ever. This fear is the result of a way of thinking about life and about art—a mindset.

Fear is understandable. The common perception is that it is nearly impossible to make a living as an artist—that there must be some secret club or singular person that can make or break an artist's career. This idea is so entrenched in our society that parents who have otherwise been supportive of their child's passion for art will force a gifted child into more "practical" careers.

But there are some predictable, key factors at play in the success of professional artists. Just like any other entrepreneurial endeavor, understanding how the business of the art world works enhances the chances to succeed.

In order to sell your art, you must understand:

- what exchange of value means for artists
- people want to buy art
- the various ways art is sold
- how you personally will sell your art

WHAT EXCHANGE OF VALUE MEANS FOR ARTISTS

Even though business is often the last thing an artist thinks about, artists who want to make a living selling their art should understand that they are running a business. This is a great thing!

At its most basic level, business is the exchange of value. I have something that you want, you have something that I want. We discuss how much of my something I'm willing to give in return for how much of your something you're willing to give.

In the case of money for physical goods like apples or paint supplies, this is fairly easy. You know about how much you want those things, and you know for about how much each of these things are commonly traded.

With art, that trade becomes a little more murky.

Learn to separate the creation of your art from the selling of your art. The two are usually not linked. The amount of time and effort that you put into creating a piece has little to do with how you sell it, other than being a good story to tell in your sales pitch. What matters to the collector is whether or not *they* value that piece of art.

Valuing art is of course about how much emotional impact the art has with the individual. You're not trading dollars for apples, where the end benefit is a good taste and a full belly. The end result for the collector is

beauty for their home, a reminder of a particular place or person, a door to opening a certain emotional experience, or a memorial of something great that happened. For some collectors, they just care about having something that other people can't have. Art is a status object for them.

PEOPLE WANT TO BUY ART

In 2013, according to the annual report from the European Fine Art Foundation, fine art sales totaled $111.52 billion. That should be sufficient to convince you that people want to buy art.

And yes, a significant portion (just over half) of that figure is from the auction of extremely expensive art from dead artists, but that still leaves more than $50 billion in sales of art by living artists.

People *love* art. They love beautiful things. They love things that challenge them and make them think. They love conversation starters and objects of social change. You just have to learn how to tap into that love.

Before you learn the best online marketing techniques, getting a grip on the fundamentals of what makes a sale will help you better understand what's happening when you are interacting with potential buyers.

An important sales rule is that people buy things from people that they know, like, and trust. That's true even of things that they love.

If you can make people know, like, and trust you, sales will happen automatically. A story about artist Melissa Dinwiddie is illustrative. Melissa attended a three-day private event with about 140 people. There were speakers on a variety of topics mostly focused on creativity, business, and poetry. At that event Melissa was chosen by vote to speak for just seven minutes. Her talk was well received and she found herself among a group of people that loved her. They hadn't seen her work yet.

On the final day of the event, attendees were invited to set up tables to sell some of their products. Melissa had brought with her about a hundred small works on paper. They are mixed media with calligraphed quotes that she calls *Art Sparks*. Melissa found herself surrounded by attendees from the event. They were asking her to just pick the piece that she thought would be best for them. Melissa ended up selling a couple dozen pieces at the event, when she originally expected to maybe sell one or two.

What does this mean?

As human beings, we like to feel that things are familiar. We are creatures of habit. We fear the new and fear being made to look stupid. So we avoid risk and gravitate toward people we like and things that are proven. The attendees of the event had gotten to know Melissa and they enjoyed spending time with her. They trusted her judgment after listening to her speak and interacting with her. After the initial person asked Melissa to pick a piece for her, everyone else thought that would be a good idea too, so they did the same thing.

But art is risky. Who knows if you will still like the art in a few months or years? What if you want to repaint your walls and the art doesn't match any more? What if the art has a hidden message you don't understand?

Art is challenging. Even something as innocuous as a pastel canvas of a beautiful coast causes potential collectors to worry that they might be making the wrong choice—what if they buy the wrong piece? What if the art is poorly made and falls apart? What if their annoying hipster friends make fun of them for buying art the wrong way?

Buying art takes time. Collectors have to figure out where their local galleries are, then get in their cars and go to the gallery. Then they have to look at the paintings and pretend that they know the difference between them while secretly hoping no one asks them any questions. Once they find something they like, they have to haggle prices with the

gallery owner. Then they have to get it framed, shipped, and hung on their walls. Unless they live and breathe art, all of these activities are abnormal and stress-inducing. That doesn't even take into account auctions, where there are weeks or months of buildup to sit in a room for hours with other competitive collectors, hoping that they get the piece that they want. Even people who have money are hesitant to buy due to the time required to do it.

These reasons are a big part of why art dealers and gallery owners have been effective gatekeepers for so long. They understand the process of buying art. They understand that the collector is stressed, and they know how to guide the collector through the process and make it easy for them.

Experienced art collectors have relationships with high-end galleries or with well-known artists. They know, like, and trust them. They are able to cut through a great deal of the time and stress that goes into buying art.

Collectors buy art because they trust the taste of the gallerist or because they believe in an artist enough to support their work. They know that the artist's personal brand is solid, and the value of the art could potentially go up. This is the reason that Damien Hirst can sell a $12 million stuffed shark and you can't sell your brilliantly composed and painted kitten.

Of course, we know that not every artist will end up being represented by a gallery with wealthy connections, and not every artist will even want that. Gallery representation comes with its own set of drawbacks. You end up catering your art to that gallerist or set of collectors, or fawning on them when they come calling. If you are capable of doing it, building a relationship with collectors directly can be equally rewarding.

The great thing is that there are ample opportunities to build these relationships with collectors yourself. The Internet has made it possible to connect with people from all over the world who like what you do. There are Internet communities built around every imaginable shared interest.

Even a small community can be incredibly supportive.

You just need to understand what makes you unique and how to find the people who like what you do. Simple to say. A lifetime of exploration in store.

THE VARIOUS WAYS ART IS SOLD

In order to be a financially successful artist, it helps to understand that there are lots of artists already doing it, and that there are many ways that it can be done. The following is not intended as a guide on the individual topics, but instead an overview of possibilities. In chapter 4, we will explore some of these topics on a deeper level.

Independent, direct to collector: selling originals directly to collectors yourself. This is the most common way to sell art. You develop your own following. You put on your own shows, manage your own website, and handle your own sales.

Gallery sales: The gallery owner or sales agent sells the art for you. You're not involved, except perhaps to be present at a showing to answer questions and be seen. This is what everyone *thinks* is the most common way to sell art, but represents only a tiny portion of how all art is sold.

Selling prints: Making prints used to be an expensive endeavor that

required an up-front investment and the gamble that such an endeavor would pay off. If you didn't sell your prints, you'd be left holding the bag. Now there are enough print on demand (POD) companies that any artist can upload images to the Web and begin selling with no up-front investment in printers, paper, ink, and so forth. Of course, you still have to learn to drive traffic to your website and convince people to buy.

Commissions: Whether it's pet portraits, people portraits, giant mobiles for hospitals, public street art, or something else entirely, commissioned work can be a steady source of revenue. You have to be a hustler when you get started, but after several years of hard work, you can build up a client base that feeds you new opportunities by referral.

HOW YOU PERSONALLY WILL SELL YOUR ART

Out of all of these business models for selling art, *how* will you sell *your* art? Which one makes the most sense to you? What I'm really asking is what kind of lifestyle do you want to lead?

What's the right fit for your personality and your stage in life? The simple truth is that there are around forty thousand artists in New York City alone trying to make it into a handful of exclusive galleries. It can be done, but it takes tremendously hard work, and no small amount of luck.

However, if the thought of managing your own business and taking care of customers makes you queasy and you absolutely *must* have someone else manage your business dealings—well, you should probably stop reading this book right now and go find a gallery that will represent you.

But if you are willing to do the work for yourself, you need to be able to answer this question: What do you want your life to look like?

If you're looking for a life where you dictate your own terms, you can do it. The life of an independent artist can include all of the following (all real-world examples from artists who do not show in galleries regularly):

Having a handful of collectors loving you enough to pay you a yearly stipend, just to make sure you continue working and that they have first crack at the new work you create. The artist Amber Jean from Montana maintains a private section of her website for these patrons, and they get first look at her upcoming pieces, before they even go to market.

Connecting with people all over the world who love you and want to see you make things. Having thousands of people watch videos of you creating new art just because they love you. Val from Val's Art Diary has 41,000+ subscribers on YouTube. They provide her with feedback and support, and they buy her art!

Your art inspires dozens of people decide to perform random acts of kindness for strangers. Those people share those experiences on your blog.

Producing an art show that sells out in just a couple of days and having enough demand to add more seats at the venue. At that show you make half of your income for the year. Canadian artist Matt LeBlanc's annual Fusion show sells out 1,200 seats in a matter of hours.

There are hundreds of examples that I could show you, but you get the idea. If you are creative, the business of being an artist can be just as fulfilling as the creation of your art.

LIMITING BELIEFS

Once you understand that art can be sold, and how art is sold, there's really nothing holding you back—except limiting beliefs. We all have inner monologues that are constantly running, telling us that what we are doing is good or bad. This inner monologue is a reflection of our unconscious beliefs about the world around us.

It is important to become self-aware enough to recognize when we are limiting our own choices because of that inner monologue.

I grew up in a culture that recognized that making money was difficult. We were very poor by most standards. I lived in a trailer park. I can still remember talking to one of my first bosses in college. He asked me how much money I wanted to make in a year, and I bravely told him that I thought it would be awesome if I could make $30,000 a year.

My boss gently laughed at me. He kindly explained that $30,000 a year is really nothing. He was a serial entrepreneur. He had built and sold a dozen companies in his lifetime, and if I wanted to, he would show me how he made money. That was also when I realized that I had no idea how much money most people made, and I had no idea how to make more. That was when I realized that my limiting beliefs were preventing me from even imagining what was possible.

Art professors will tell students that they had better make art for the love of it because they will never make any money. The students learn the stories of Van Gogh and Mozart and tell one another during smoke breaks that these artists are the ones that they should emulate. I have received dozens of e-mails from art students letting me know that this happens on a regular basis. I even know an art professor who almost lost his job over a disagreement with a colleague about whether or not they should be teaching their students business skills.

But the independent artists I know never bought into the myth of the starving artist. They were never immersed in that culture. They just put their head down, did the work, and only later found out that artists aren't supposed to be making a living from their work.

Think about terms like *starving artist*. That phrase is often thrown around like its some sort of joke. Artists will throw starving artist shows or sales, in some kind of semiserious plea for money. Using this kind of language, even as a joke, affects you.

Other bits of language that artists use to limit themselves include:

"I'm not a business/computer person." This is an excuse for being too lazy to learn the basic skills necessary for running an art business. You let yourself off the hook and abdicate responsibility.

"The economy sucks." Sure it does, but what does that have to do with you? Very little. There are artists making a living despite the economy. The economy is the concept of everything as a whole. Some pieces are doing well, others not as well. You can make it. Find a way.

"I don't have time/money/other resources." I get it. We're all busy. We're all resource-constrained. Successful artists find a creative way around resource constraints to reach their goals. If you can work around constraints when creating art, you can work around them in your business.

"Important person X thinks I should do Y." I hear this one a lot. The artist's spouse thinks they should give up. The artist's teacher thinks they should work on their technique or find a gallery dealer. The artist's friend thinks they should paint more commercial work. There's only one person who can decide what you do. You know your work. You know what brings you joy. You know your level of technique. The artists who succeed at being both commercially successful and fulfilled are the ones that have a vision of what they want their art to be and then stick to it.

"My gallery owner/agent sucks." Well, first, good on you for getting into

a gallery and finding an agent and, second, so what? They don't owe you anything. Remember, they are a business. Have you talked to them about why they're not selling your work? We all look after ourselves first. How can you make your partnership with this person a higher priority? If you can't, it might be time to find another agent or gallery that will take you seriously or make you their priority.

Sometimes the agent or gallery just isn't a good fit personalitywise. You might be a great artist but if the primary collector clientele aren't into your work, the gallery owner isn't going to push your work over something that his buyers prefer.

"I'm not a good enough artist." Work matters more than talent. Every art teacher will tell you that the artists who make the best art are not the ones that are the most naturally gifted, but the ones that work the hardest. They will work at it until they get it right, because they know that it's not just going to come to them. The same is true in business. Sometimes you get lucky, but most of the time you build your business person by person.

HOW TO SHAKE LIMITING BELIEFS

We won't spend a ton of time here on how to escape limiting beliefs. There is a whole industry built around helping people escape limiting beliefs. There are books and seminars and specialists. What follows is a small set of suggestions that help me and some artists that I know.

Make a sale. Nothing helps you shake off the poverty mindset like making some cash. Even if it's a small amount of cash. There are all kinds of ways to turn around a quick buck as an artist. You can set up a little display on the street. You can ping your mailing list and let them know about

new sketches or studies you have available. You can even set up an easel in a busy area and offer to do drawings or small paintings for people. You might scoff, but I know successful professional artists who do this on a semiregular basis just to remind themselves of what it's like to sell.

Surround yourself with positive people. You might be amazed by the number of people who e-mail me to tell me that my blog has made them believe, for the first time, that they actually can sell their art. They have been told no all of their lives by parents, friends, and other well-meaning people they love and trust.

Artists are a morose group sometimes. We tend to sit around and tell one another horror stories about how difficult life is and how much better it would be if only a different life had picked us. We share horror stories about bad sales, bad collectors, bad art supply stores, and bad professors.

It's important to surround yourself with people who can help lift you up. I recently attended a screening of a great little documentary called *Indie Kindred*, which follows the lives of several artists and shows how their small group of friends supports each of them individually. This movie is a documentary about what is commonly called a mastermind group or accountability group. Napoleon Hill's book *Think and Grow Rich* is a great resource for understanding how mastermind groups work and how to start your own.

Socialize. One thing that has been made abundantly clear to me: artists everywhere lead isolated lives, and this can be detrimental.

I don't want to generalize, but it seems that most artists tend toward introversion. It's easier to stay in the studio with your art than it is to get out and meet people. That's not a bad thing in itself. The world needs deep and sensitive thinkers. If you feel drained by people, then you're probably an introvert—and that's okay. But it's worthwhile to seek ways

in which you can comfortably meet and be around people if that's something you have trouble with. Susan Cain's book *Quiet* provides excellent guidance on how to be in the world as an introvert.

Exercise. It releases endorphins, makes you happier, and being happier makes you more creative and better able to do business. Keeping a regular exercise routine will also help you avoid some common art-making physical problems like carpal tunnel and back fatigue.

The Praise File. Whenever I get an e-mail from someone telling me how much they enjoyed a blog post or a class, I drop it into a file called "Praise." I know a number of artists and entrepreneurs who do this.

Not only is it a great way to keep press clippings and testimonials, it's also a great way to make you feel better about yourself when you fail at something or when someone criticizes you. Something bad happens to you? Just pull out your Praise File and look at the nice things people have said. The world wants to tear you down—its important to have a way to build yourself back up, and the Praise File works well for me.

There are a number of other myths that "starving artists" believe to be true. These are all ways of thinking about your career and your life that impose artificial limitations on what you can accomplish.

"Starving makes me a better artist." My biggest pet peeve of all time. I see so many artists who refuse to take a business class, or refuse to learn about financial planning, and think that they are a better artist for it. Picasso was rich. So was Norman Rockwell, Dalí, Matisse, Shakespeare, Elvis Presley, and a litany of other artists.

"Money is evil." Money is just a tool. It is neither evil nor good. It does what you tell it to do. It's like a crowbar or a hammer. The pursuit of money is necessary to live in most places, so learning to value your art in terms of money simply allows you to feed yourself and provide shelter for your family.

"The Big Break will come." Instead of creating a plan or creating something themselves, the starving artist believes that their Big Break will come and they'll be instantly rich, famous, and happy. Big Breaks are rare and they come with their own set of problems—or haven't you seen VH1's *Behind the Music*?

"I don't need training—I'm brilliant." Sure, you might be brilliant. More likely, you were just right for a particular role, painted one canvas that resonated, or had some other one-shot hit. Brilliant artists who have training have long-lasting, productive careers that are fulfilling and leave behind a body of work that endures.

"My family and friends say I'm amazing." Of course they do. They love you. Do you trust their opinion? It's good to have supporters and people who love you, but to have a sustainable career, you need (unfortunately) the approval of people who don't know you. That's why the audition phases of *American Idol* are so painful to watch: many artists have never ventured out of the family bubble.

"I need a day job." While you do need to make some money, you also need time for your art. If your day job is killing your creativity and not leaving you enough time to work on your craft, then something has to change. I've seen it happen. If your creativity goes away, your ability to do your day job will too.

"I don't need a day job." On the flip side, if you simply spend your days being artsy and don't make real-world concessions, you won't be able to get training, buy supplies, market yourself, or feed yourself. It's pretty hard to be creative when your stomach is growling.

"It's okay to sell out your values." Just because being a working artist is difficult doesn't mean you should try to find the easiest route. You don't have to make art that is safe be-

cause you think people will like it. Many artists I know that are wildly successful are in that position because they created the thing that makes them happy.

"I shouldn't charge too much for my work." Some artists are so excited about finishing a project and getting attention that they don't realize that they should charge more for it. There are endless stories of famous artists selling their work for a pittance before they become well known. Don't be that guy (or gal). If your work flies off the shelf, it might be time to charge more for your art.

"I can't say no to any opportunities that come my way." You have only so much time to create. If you take a commission that doesn't pay or pays too little, you won't have time for the ones that do. Decide how much your time is worth, and don't take anything less than you set for yourself.

"I don't need technology." Some artists believe that selling or displaying their work on the Internet cheapens it. You really, really need to be found online. Even if you don't sell your work directly, people will research you, your art, or your show before they decide to purchase.

"I'm doing all the right things with my business." If your business is doing well, you're making enough money to be happy, and you don't feel stressed every day about time or money, then great—but far too many artists are just scraping by and saying to themselves, "I'm doing everything right. What's wrong?" If it's not working, you're not doing it right. Get some help.

FIND YOUR NICHE AND
YOUR IDEAL COLLECTORS

We ask ourselves, Who am I to be brilliant, gorgeous, talented, fabulous?
Actually, who are you not to be? Your playing small does
not serve the world. There is nothing enlightened about shrinking
so that other people won't feel insecure around you.
—Marianne Williamson

Early in 2013, I took on a new coaching client. Emily (not her real name) is a young artist, just out of college, who had some mild success selling oil paintings of flowers, trees, and birds. They were traditional paintings, done in a literal style—and she was really unhappy with what she was doing.

We spent a lot of time talking about how she could better market her paintings. We talked about putting them on greeting cards, finding local shops that might be interested in selling prints and/or originals, and approaching a couple of the small galleries in her hometown.

Just before we hung up the phone Emily decided to show me a piece

of her art that was a little bit hidden away on her website. It was completely different from everything else she was doing. It was full of bold color, texture, and it had soul in it. You could tell right away that this was done by someone who put thought and meaning into what they did.

I asked her why she hid it several pages deep on her website. The story she told me broke my heart. Emily felt that her family would not understand or approve of the kind of art that she really wanted to make, so she never showed it to them. Putting it on the website at all was an assertion of who she was—but she was still afraid to put it front and center. We talked about it for a while, cried together, and finally she agreed to put it out there. She even made a video introducing herself and her art and put it on the home page of her site.

Fast-forward six months and Emily is a thriving young artist. She has more commission work than she can handle, and her website is full of testimonials from happy portrait clients and print purchasers.

There are a lot of artists like Emily. In fact, I think there's a little bit of Emily in all of us. We are sometimes afraid to put our best work—our most important work—forward, though we may not even know it. I firmly believe that each artist has something that they are uniquely qualified to express. It just flows out of them.

WHAT IS YOUR UNIQUITY?

I first heard this word talking with my friend Michelle Ward, from WhenIGrowUpCoach.com. Michelle is a coach for creative people who are looking to make a career change. Michelle has an effusive personality that makes everything around her bubble with enthusiasm. She makes people feel like they can do anything.

Michelle talks a lot about Uniquity. Uniquity simply means the state of being unique. It's the thing about you that sets you apart from all of the other people in the world. When someone says Picasso, what comes to mind? Probably Cubism and an irascible personality, right? That's close to what I'm talking about.

In the business world you might hear Uniquity described as Unique Selling Proposition, Competitive Advantage, Blue Ocean Strategy, or (as my buddy Jason at Internet Business Mastery calls it) the Single Motivating Purpose. Uniquity is the key to standing out when you are trying to become a successful artist.

If you paint flowers, you might be just the best flower painter in the whole world—but realistic flower paintings have been done, a lot. It's pretty tough to make a living doing that. You're competing against all of the other artists who make realistic flower paintings and all of the photographers that take pictures of flowers. How in the world do you stand out and be noticed and remembered?

In some cases, you can differentiate yourself through the painting itself. Perhaps you are really an exceptional detail painter. Perhaps you're really great with color. Of course, there are a lot of artists who are pretty great with color.

In most cases, however, your differentiation is going to be a combination of your unique take on a painting that is different from what all of the other artists do. Perhaps you completely deconstruct the shapes like Picasso did with Cubism. Perhaps you use swirls and loops like Van Gogh. I'm not saying you should try to imitate what Picasso and Van Gogh did. I'm saying that you should consider whether you have any original, unique take on the subject matter. What is your art saying? Why are you saying it?

These are things that they tried to teach you in art school. Your teachers wanted you to look deeper so that you could have something to say. This

matters not only in making art with meaning, but also helps in business by giving you a way to stand out from the crowd. You don't have to start a new movement in art, but it certainly doesn't hurt to be true to your voice.

The other part of your Uniquity is you. Your mind, your body, your physical voice—you. Artists are fascinating to people. We conjure the unseen. We take ideas that people are only subconsciously aware of and make them physically present. We address taboo topics with grace, with humor, or with direct confrontation when necessary. Artists have the ability to save lives, to cause riots, and to inspire entire social movements.

People really want to know about the artists. They want to know who you are, what you are like, what your inspiration is for you art, and how they can connect with you. If you are self-aware enough to know these things you can use them to your advantage. There are artists who do this spectacularly well. They build up world-renowned personal brands. Don Thompson's book *The $12 Million Stuffed Shark* does a great job of detailing how artists like Damien Hirst partner with gallery owners and famous collectors to cultivate a certain public perception. This combination of branding, personality, and association with success creates incredible results.

How do you define your own Uniquity? It's a combination of introspection, market observation, and a willingness to take certain kinds of risks.

If I were going to turn Uniquity into a mathematical formula, it would look something like this: Inspiration + Subject + Personality = Your Uniquity.

Your inspiration for making your art matters to people. They want to understand where your art came from. You don't have to come right out and say it, but you can hint at it and lead people down the path that you want them to follow and let them discover it for themselves.

You can create your Uniquity in an intentional way. You can set out with a specific type of personality and perception that you want people

to have of you. Andy Warhol was inspired by breaking down people's notions of what art is, and this served to catapult him to the forefront of the discussion of art and financial success. This was quite intentional on his part (though he may not have anticipated that his work would eventually sell for more than $100 million). In Warhol's book *The Philosophy of Andy Warhol*, he said, "Making money is art, and working is art and good business is the best art."

You may not want to create your Uniquity in this sort of calculated, intentional way, and that's okay. It takes a specific type of personality to build a massive empire from art. Even if you want your art career to grow more organically, you can be more self-aware and more intentional in the way that you market your work. Many artists hate business, but the artists who are financially successful understand the principles of wealth and apply them to their art career.

You probably have some idea what makes your art unique. Most artists have a handful of subjects that they like to examine, a certain painting style that makes them really happy and joyful. To get an outsider's perspective on what makes your art unique, a great way is to ask your previous collectors. In my coaching business I will sometimes ask artists to call up former collectors and ask them why they bought the art, what kind of emotional reaction they had the first time they saw it, and how they describe the art to other people. These words are usually full of emotional terms like "it spoke to me" or "it just made me smile." Sometimes collectors will say things like "It made me think about [fill in the blank subject] in a new way" or "I'm not sure, I just knew I had to have it."

This is useful feedback. If lots of people tell you that your art makes them happy, then that message should make its way into your marketing materials. If your art makes people reconsider preconceived notions, you should talk about this.

These are basic clues that any good writer will pick up on. I can't tell you how many conversations I've had with young artists who tell me that they are taking a writing class and that they hate it so much. If you are an artist in art school right now, take your writing class seriously! It will always be valuable to you!

But remember that while your Uniquity will help you understand how to appeal to people, not everyone will like your message. Many artists make the mistake of trying to sell their art to everyone they know. You will have more success if you focus on the people most likely to be receptive to your message.

These people are your target collectors.

Some people call them your tribe, your "right people," or your fans. Whatever you call them, they are the most important people in your business—not the gallery owner, not the publisher or the licensee.

You should know everything about your target collectors. Where are they from? What is their approximate income? What kind of hobbies do they have? Pets? Children? Where do they spend their free time?

Again, if you have a record of sales then you have a good place to start. When talking to these collectors, you can find out about them during sales conversations. If you have a mailing list you can and ask them questions. I know several artists who do something like this: whenever a new person signs up for their mailing list, the confirmation e-mail has a short message that asks the collector to share with the artist what they like about collecting art, who their favorite artists are, or what intimidates them about buying art.

Once you know a little about your ideal collectors, you can start to position your art in very specific ways. Some art lends itself to this quite naturally. Melissa Dinwiddie's ketubah art appeals to Jewish customers, as the ketubah is a part of Jewish culture. As she made more sales

Melissa also figured out that her art appealed to gay couples looking to get married. Melissa put together a few marketing messages to that effect, and gay weddings became a substantial part of her business, and she had to make only a few minor changes to the work she produces.

Other art takes a little more work to find a niche. Early in his career, Matt LeBlanc, the Canadian abstract painter, knew that his work needed a niche, so he chose price. After researching all of the other abstract painters in his region of Ontario, Matt chose to price his art in the mid-range tier of $300 to $1,000. He intentionally began creating pieces that he could sell in that price range and make a profit on. These pieces were relatively small pieces that he could create in just a few hours. People loved them and Matt's career took off. He was able to leverage the interest people had in inexpensive art into an annual show that is now tremendously popular. The Fusion show is a live stage performance piece where Matt shows off his painting process, shows his art as fashion with models, and invites attendees to buy his art. In 2014 Matt's show sold out within a couple of days. He increased the 800 seats he had prearranged with the venue to 1,200 and sold that out too. He also expanded the show to multiple locations and plans to go even bigger.

WORKING IN A SERIES

You may have noticed that many of the most successful artists in the world create series of art where each piece is similar in theme. Perhaps they have similar colors, similar subject matters, or similar emotional qualities. This is usually on purpose.

Working in a series helps you in several ways. First off, it allows you to deeply explore a theme. Gwenn Seemel's work in her *Crime Against*

Nature series is a powerful way for her to explore gender identity. She created several dozen pieces.

Gender identity is a topic that matters to her a great deal, and you can tell from looking at the work. Simply spending that much time thinking about the composition of each piece, and then the execution of the ideas, gives weight and depth to your work.

Second, giving that much thought to a series will help with your marketing. When you create art around topics that you care about, you'll naturally have more to say when it comes time to tell stories about your art. Be sure to journal throughout your artistic process. Capture the thoughts and emotions around the creation of each piece. Gwenn used the notes from her research and creation to publish a book that included her art, and that book became a launching platform for the next phase of her career.

Third, working in a series gives your collectors options. They might really like the topic, and having a variety of pieces to choose from in that style and subject means they can find something they really like. If a piece they really like is already sold, they have the option of finding something close to it instead.

FINDING YOUR IDEAL COLLECTORS

How do you find your ideal collectors? It starts with doing some research. Let's say that you make beautiful oil paintings that capture the essence, power, and majesty of wild animals like tigers, dolphins, and bears.

Thinking about who might like those paintings, I can imagine that there are lots of people who are interested in having a large tiger painting in their home. I know I would. This is the situation in which artist Taylor N. found herself in 2012. She and I talked about it and I sug-

gested that perhaps she should do some research into what online communities there are that support wildlife. As you might imagine, Taylor had some resistance to the idea. "I'm not a computer person," she said.

Cue me blowing a fuse, snapping like some robot that just got tricked into trying to drink water and short-circuiting. I hate that phrase. *I'm not a computer person* is an abdication of ability to learn something new. It's a refusal to be a part of contemporary society. I'm not talking about conformity—I'm talking about simply understanding that the world you live in is largely shaped by computers and the Internet.

As you likely know by now, I strongly believe that an artist who ignores the Internet dooms their work and their self to irrelevance. If an artist's place is to see what others cannot see, and translate that into the physical, sensory world, then they must understand what drives contemporary culture and thought. So, for those artists who don't spend much time online, I'd like to introduce you to the idea that the Internet is a tool that people who like similar things use to get together. When they form their own niche groups online, it's called cyberculture.

In times past, people united around shared identity—think country clubs or barbershops. With the advent of mass media (newspapers and television), people often united around shared events—think *I Love Lucy*, the Challenger disaster, or 9/11. That still happens, but increasingly people are uniting around shared affinity. Previously, people with narrow interests might be considered strange, and they might have felt isolated because they didn't know anyone else who liked what they did.

Online communities are diverse. With a quick Google search, anyone can find a group with shared interests. There are places that everyone is aware of, like Facebook. There are also places for every sort of exotic interest. I love Dungeons & Dragons. There's a website for that. You might love Webkinz, knitting, dirt bikes, or even cyborg anthropology. There's a web-

site for that. Each of these communities has its own culture, its own distinct slang and worldview. They might be anything from very loving and nurturing to bordering on anarchy, held together by the weakest of ties.

Cyborg Theory states that because of the way that machines and objects have become a part of our everyday life, we are all cyborgs (part human, part machine). We don't think about this because it's so natural. Every day you wake up, use a machine to brew coffee, blend juice, drive to work, and perhaps even create your art. We touch our machines, we name them, and we perceive them as part of who we are.

The Internet and digital communication like texting or video chat are the same way. Many people, especially those under thirty, wake up and check their Facebook page on their smartphone while drinking their morning coffee. They don't watch the morning news or even read the paper. They get their news from friends who share links to important stories.

When something tragic happens, many people don't pick up the phone. They share it on a blog or community page. The digital community rallies around us. Facebook has dozens of private groups for people who have chronic illnesses, helping people learn to manage their condition and giving them a sense of support.

Another important concept is "weak ties." This is a term introduced in the research of M. S. Granovetter in his paper "The Strength of Weak Ties." Imagine you are at a cocktail party. You are in a pretty dress, or a nice suit. You're talking to your spouse, laughing and having a good time. A man walks up and starts talking to your spouse. They know and like each other, and your spouse introduces the man to you. You chat pleasantly for a while, then he sees someone else that he knows and excuses himself. This is all very normal.

At a very large cocktail party, this kind of activity might happen a few dozen times. There are perhaps a few hundred people, anzd you

can't meet all of them in one night.

The next day, your spouse's friend walks in front of your house on his way somewhere. He sees you on the front lawn and stops, says hello, and mentions that he's looking for a job. Turns out that you just happen to know someone who is looking for an employee. Your spouse's friend has the right skill set, and you make a match.

You barely know each other, but you have made a powerful impact on this person's life. That is the power of weak ties.

The Internet amplifies the power of weak ties many times over. Twitter, Facebook, and other niche social networking sites are like an always-on cocktail party where everyone is invited. You are introduced to other people through various conversations. Some you like. Others you loathe. You help some. Others help you as the party continues.

For an artist, weak ties lead to art sales. A person who talks to you about your art might mention it to a friend. That friend might be interested enough to seek you out, or at least remember the conversation when they come across your art a few days or weeks later. A five-minute conversation could lead to a $10,000 sale. You never know where a conversation is going to go. Incidentally, this is one of the reasons that you should treat people with kindness and grace. To be purely mercenary about it, treating people with respect leads to more sales. If the person

you mistreated tells their art collector friend about it, you may have just lost a sale when they associate that bad behavior with your art.

How can you as an artist use the Web to build these weak ties to the communities that might be interested in your art? Blogging, e-mail newsletters, and various forms of social media all act as ways of building relationships with fans and potential collectors. This content also serves to remind people that you exist and that they like you. Each of these media outlets serves as a different way of participating in that ongoing cocktail party. In the next few chapters we will explore in-depth tactics that are proven to help artists like you sell more art. Right now, I want to share with you some of the ways I use the Web to research different market segments to help artists find their niche.

TOOLS FOR RESEARCH

Professional Internet marketers use a variety of tools to figure out how popular a website is, who is linking to that website, and approximately how much traffic that website gets. In this section, I'm going to share some of those tools with you and give you a brief overview of how to use them to find a good niche for your art.

Analytics on your own site

The best research tools are your own website's traffic analytics tools. If you're using a service like Blogspot or WordPress.com, they should have a dashboard that tells you where most of your traffic comes from. If you don't have an analytics dashboard, I would recommend installing some sort of analytics software. Google Analytics is free and easy to install.

You'll want to look at the following information:

Search keywords. This is quickly becoming a harder-to-find stat, but your analytics tools should give you some idea of the keywords that people are typing into search engines when they find your site. Sometimes this will make sense. For example, perhaps you make bronze buffalo statues. If you're seeing that people are finding your website when they search for the term *bronze buffalo* then you know the search engines have ranked you highly for that term. Yea!

If you see that you are not ranking well for the art that you have on your website, keep reading. Chapter 6 will help you rank better in search engines.

Referrals and social. In Internet marketing parlance, referrals just means the websites that sent you traffic via some sort of link. In many analytics packages, social media sites like Facebook are included in referrals. The websites that are sending you referrals tell you a lot about the people finding your work. Is it mostly artcentric websites like WetCanvas? That's probably other artists who are sharing links to your work. Is it the *New York Times* website? Then you probably got written up in the arts section. Do you have a bunch of clicks from Facebook? Someone with a large number of followers may have shared a link to your work. There's a lot to reveal here.

External research tools

Beyond Google Analytics, there are some tools that you can use to look at other websites to figure out where your target audience lives.

Google searches. Do a Google search for the style of art that you make (as specifically as possible) + the word *blog*. You'll find a host of blogs and artist sites that are in the same genre. Most of them will be really awful.

Use them as an example of what not to do, stealing a few examples of designs you like and marketing tactics you like.

Use the Moz toolbar mentioned a few paragraphs below to get a good idea of how much traffic these sites get and who is linking to them. Note that the toolbar will show millions of monthly visitors to artist blogs like name.blogspot.com or name.wordpress.com—this is total traffic to Blogspot.com or WordPress.com, not to the individual artist's page. For artists who aren't using their own domain, it's very difficult to figure out how much traffic they have. In those cases, you might look at how many comments their blogs have or how many Facebook fans they have.

Another interesting Google search is to look for the subject matter you make art about (e.g., the Oregon coast, ducks, hibiscus, or Paris). Look for online communities around those topics. You might look for the Oregon coast tourism board, the Audubon Society, gardening websites, or sites where people plan trips to Paris. Any of these would be good places to learn about your target collector.

You can do the same thing with other areas your target audience might be interested in. If you share hobbies with your target audience, this is a good idea. A pet portrait artist might look at online pet communities. If you live in an area with a popular annual event like a state fair or a big race, look for some online communities around those events; it would also help to show up at those activities with your art.

Artist blogrolls. Many bloggers have a list of blogs they read on their site. Look for long lists with titles like "blogroll," "blogs I read," or "great people." You'll start to notice patterns. Who gets listed a lot? Think about why they get listed. Are they part of the same community? Read a few of the artist's blog posts. Are these artists friends? How can you get listed in these blogrolls?

Twitter search. Twitter produces more than one billion tweets per week!

That's a lot of real-time data about what's happening on the Internet and in the real world. People update Twitter from their smartphones all the time. Spend a little time there to see what artists are tweeting about, and who is responding to them. Use the same searches that you used on Google.

Facebook graph search. Again, use the same set of searches. Type in your search and after you get the results, click the "More" tab and select the "Groups" tab. You can find some very active Facebook groups. Avoid the artist-centric groups. You want to find the places where collectors hang out! In a quick search, I found more than ten groups related to the Oregon coast, and dozens of groups related to ducks.

Want to see which artists have large followings online? Look at Facebook Fan Pages. Grab the list of artists you've already looked up, or just do a search on Facebook for the kind of art that you want to do and see who comes up. It might surprise you to see that there are already a bunch of artists who have substantial Facebook followings, and that they are making sales off those Facebook fans.

Also, you can do some very sneaky research with Graph search. Try some of these example searches:

- Pages liked by people like [your Facebook page]
- Pages about [insert your style/medium]
- Pages liked by my friends

The Moz toolbar is a web browser add-on toolbar provided by the search engine research company Moz. The toolbar shows you a few useful statistics:

Domain authority (shown on the toolbar as DA) is a logarithmic rank from 1 to 100 that shows how important that website is according to search engines. It takes into account a variety of signals including how

many links there are to a website, the importance of the websites linking to that site, and other factors. Basically, the higher the domain authority, the more traffic that website receives.

Page authority (shown on toolbar as PA) is also a rank from 1 to 100 and shows how important a particular page is on a website. It's similar to domain authority, but only measures a particular page instead of the entire website.

MozRank (shown on toolbar as mR) is Moz's own measurement of how much "link juice" that page passes to another page linked to it.

The Moz toolbar also shows how many links there are to that particular page and how many times that page has been shared on Facebook, Twitter, and Google Plus.

After doing your research, test your muse

Finally, I'll say that while research is important, the final decision on what to do and how to do it comes down to you as the artist. Figuring out where your audience is spending time is just part of the puzzle.

It's your work and your life. Artists remake new markets and forge ahead into areas that others can't see. That's what makes artists unique and interesting. Once you've done your research, set it aside and think about your artistic vision, and then do what you know will take you down the right path. You have the vision.

All of these tools together are meant to give you the resources you need to figure out which communities you can participate in to grow awareness of your art. Hopefully by using them you can find a few websites where people are enthusiastic about what you do. Over the next few chapters I am going to explain the basics of how to maximize sales from your participation in these communities.

GOOD ART DOES NOT SELL ITSELF

In order to be a financially successful artist, it helps to understand that there are lots of artists already doing it, and that there are many ways it can be done. When you know what's possible, you can make an educated decision on how you would like your career to progress.

Before we jump into what I have categorized as five ways of selling art, here's something you should know: Good art does not sell itself. The myth that an artist just has to be industrious and someone will magically pick them out of their studio and make them famous is just that: a myth. It doesn't happen.

One would think that this is just obviously not true, but the idea persists. What does "good art" mean anyway? What if you are an artist that lives in the middle of nowhere Montana? What if your style isn't "commercial"? What if you make doilies with dirty words on them?

These are not just existential questions. What good is art if you don't tell anyone about it? You want people to see your work, right? You need to tell them about it in the most effective, efficient way possible—that's what marketing is at its base level. The artists who are the best at this actually know their collectors and have great friendships with them as well as business relationships.

At the core, there are five ways to sell art. Some artists choose to specialize in one area for their entire careers. Some artists do a combination of all of them. Some artists start out doing just one and then expanding to other areas as their needs change and demand for their work grows.

The five ways to sell art are:

- Selling through galleries
- Selling direct to collectors
- Selling prints and products
- Selling commissions
- Licensing

Selling through Galleries. While it's not what this book is about, this is what most artists think of when they think of selling their art. The gallery owner or sales agent sells the art for you.

Being represented by a top-tier gallery is a dream for many artists. You'll be invited to lavish parties with celebrities and wealthy people from the upper social strata. There's wine and fine food. You're written about in newspapers and major art publications. Museums clamor for your work. You're treated like a celebrity. It's very exciting. Your work might even sell for six figures or more.

Being a gallery artist is the most commonly talked about way to make a living as an artist, but it's actually the rarest. In 2009 alone

over twenty-nine thousand students graduated from colleges in the United States with an art degree of some kind. Multiply that by the last ten years, and then also add the number of self-taught artists that want gallery representation, and you start to see that getting into a top-tier gallery is daunting. There are more than six thousand galleries in the United States, so that makes your odds of getting into *any* gallery about 50:1.

And here comes the most depressing part: Even if you get into a gallery, there's no guarantee that you'll make a living as an artist. Experienced artists will tell you that many galleries don't even make a profit. It's not all wine and roses. Many galleries that existed before the Great Recession of 2008 have closed. Running a gallery is similar to building a business as an artist: Anybody can start, but it takes skill to make money over the long term. There are perhaps about fifty to a hundred galleries that would be considered elite galleries that continually bring in solid revenue for their artists. Those are 3,000:1 odds for all artists trying to get into these galleries—similar to the odds of making it as a professional basketball or football player.

Many artists that I speak to in my consulting work would prefer to be in a gallery. A handful recognize that they would prefer to be on their

own because they retain control over their own schedules and relationships with their own collectors. I've met a number of artists who made solid six-figure incomes for ten to twenty years or more, and when their gallery dropped them or went out of business, they were suddenly without income and had no resources to start sales because the gallery had all of the relationships with collectors.

I often tell young artists that if they want longevity in the art business, they need to develop their own relationships with collectors, in addition to whatever the gallery does with them. Galleries are great for artists who are so painfully shy that they can't talk to collectors, but these artists need to understand that if something goes wrong with the gallery, they are out of luck, and they will have to start over completely.

Selling Direct to Collectors. Selling directly to collectors is a great way to make a living. Newspapers and art magazines write about the big gallery sales and art auctions, when something goes for $100,000 or more. The art world is abuzz when a Jeff Koons piece sells for $65 million. Artists should recognize that six-figure sales are outliers. It takes a tremendous amount of effort to sell art for this much money, and a lot of people are involved: the artist and his assistants, the gallery staff, the auction staff, and event planners. Quite frequently, previous collectors with an interest in seeing their artists appreciate in value are also involved. These kinds of sales are major events pulled off by people with massive resources.

They're also extremely rare.

Selling direct to collectors is the most common way to sell art. Think about the dozens of art fairs that happen around the country each year. There are hundreds of street fairs, home shows, neighborhood parties, community gatherings, and similar events all throughout the world. Every time I travel to a new city, I usually end up buying a piece directly

from an artist who is selling their work on the street and I talk to the artists. I've spoken to a number of artists who make over $40,000 per year from selling their work on the street, and they build from there.

You develop your own following, put on your own shows, manage your own website, and handle your own sales. You might not sell a piece for $12 million, but that's okay. If you can sell a handful of pieces each for $5,000 to $10,000 per year, you'll have a solid income, and you don't have to depend on the big gallery machinery.

Independent artists are the focus of this book. Artist Shirley Williams was on a career trajectory where the price of her art was doubling every couple of years as she got into better galleries and museum shows. One day she sat down and ran the numbers and realized that even though she was becoming quite well known and was selling pieces for low five figures through her gallery, she was in fact losing money because of shipping and related costs. "I don't want to be famous. I want to make my living from this," she told me in an interview. When she pulled her smaller work out of galleries, she was able to sell them at a lower price point and make more money.

From there, Shirley pulled her larger pieces out of the galleries as well and eased down the prices, and suddenly her local market became enthusiastic about her work. Even though the art world elite ignores her now, and museums are no longer interested in her work, she has made a solid living from her work for twenty years.

The great thing about being an independent artist is that you get to choose how your art is perceived in the world. Your shows are 100 percent your own ideas and your marketing actually becomes an extension of your art. You form connections with your collectors and fans. In many cases, real friendships develop over the years. "I'm the happiest when I'm in control of my career," Shirley says.

Some artists learn to start a movement with their art, inspiring people to take action for specific causes. Gwenn Seemel's series *Crime Against Nature* has become a focal point in what the media says about her. Gwenn has a platform from which to talk about gender issues. *Scientific American* magazine featured her on its website. The American Association for the Advancement of Science invited her to talk on the commonalities between science and art. Her platform for talking about important issues is also a platform for selling work and landing commissions. The visibility brings in sales.

The difficult thing about being an independent artist is that you must learn to do all of these things yourself. You must learn basic skills in marketing, sales, printmaking and/or ordering, framing, shipping, and handling money. You are an entrepreneur. You own your own small business. This is both empowering and overwhelming, and usually requires a big mental shift.

Eventually, as you achieve some success, you will have the ability to hire people to take over some of the things you aren't very good at doing. I like to outsource bookkeeping, web development, and customer service correspondence. Many artists also like to hire someone to handle shipping.

It also takes self-reliance for this kind of a career and understanding that what the fine art elite thinks doesn't matter, because you care more about making your art and connecting your art with people.

As a side note, it has been my experience that most of the successful independent artists that I know did not go to art school. I know artists who were oil pipeline engineers, social workers, stay-at-home moms, welders, advertising executives, marketing executives, and chefs. These artists are not only the most successful independent artists that I know, but are also among some of the most successful people that I know. They

own six- or seven-figure businesses, have long-lasting marriages, children, and are pillars in their communities. There's something about being self-taught that allowed these artists to avoid the glitzy, image-obsessed gallery world that many artists seek.

Selling Prints and Products. In the past, making and selling prints was risky. If you didn't sell your prints, you would fail to make your money back. Now technology has evolved to make selling prints very low-risk.

Some artists will choose to print their art themselves. This can actually work out really well for the right artist, but you need to have a specialized set of skills (or work with someone who does) and be willing to make a minimal up-front investment in printers and materials.

Fine Art America, Saatchi Art, and Art.com are all examples of companies that offer fine art POD services. In addition to selling fine art prints, there are endless companies that will put your art on a virtually unlimited array of products. Redbubble, Zazzle, and CafePress, to name a few, will put your art on mugs, calendars, T-shirts, and hundreds of other products. (For a complete list of POD companies, you can visit the free member resources library on our website at courses.theabundantartist.com.)

The quality of prints from each of these companies doesn't vary by much, contrary to what many artists think. It isn't discussed very often, but most of the print fulfillment for these companies is actually handled by just a handful of printers. The variation in quality of the print often has more to do with the quality of the original image, the medium it's printed on, and the personal taste of the artist.

While they can be great partners, bringing in huge amounts of revenue for the right artist, you should be aware that POD companies usually have onerous terms and conditions that give the company the right to change policies at their whim. This has resulted in pricing changes that

sparked controversy and outrage among artists because the new terms cut into artists' profits and benefitted only the POD company.

These POD companies exist not to make the artist rich, but to make their owners and investors rich. As you build up your visibility on these sites, you are building up the sites too, and the POD companies will usually use the space where you are promoting to also promote other artists, just in case the people visiting that page might like something other than your artwork.

Whether you choose to work through a POD company or print yourself, it can be very lucrative. One artist that I spoke with, who makes popular paintings of the American Southwest, sells $30,000 in prints every month!

A myth about prints: They don't cheapen your originals. There are literally millions of prints of the *Mona Lisa*, and people still flock to it to see it and take pictures of it. The same is true for thousands of images.

Selling Commissions. Depending on how they're done, commissions can be a source of endless frustration or a font of creative joy. If artists position themselves as creative authorities and not clock-punching order takers, then they can approach the piece with the same sense of artistic vision that any other piece might inspire.

On the other hand, artists can also end up being a sort of short-order cooks, churning out pieces at predetermined sizes and colors with too much control and input from the client, killing all of the creative joy that goes into art making.

The principles of selling commissions are the same as selling originals direct to collector. You are in charge, and you get to decide what the terms are. Customers may request specific changes, but ultimately you are the one that decides what the outcome of the commission will be. It helps to put in your contract that the collector gets one round of revisions

or input, and that you are the final arbiter of the finished image. The collector is hiring you for your artistic vision.

Licensing. As consumer culture grows, more products of all kinds are sold. These products need professionally created images to make them more salable. Companies large and small will pay to use your art on their products.

If you decide to start going down the licensing path, be prepared for a rabbit warren of legal contracts, marketing executives, agents, and other business lingo. You should also be prepared to customize your art to the company's demands. They may like your vision, but they may want it in a different color, with a different border, or as a mouse instead of a cat. If you can't handle that kind of compromise in your art, then you probably won't like art licensing.

On the other hand, art licensing can be incredibly lucrative. At the highest end, artists can make six or seven figures in passive income. If you get a deal with a company that sells a popular product, you'll get a quarterly check with a fee for each individual item sold. That can be fantastic!

This book won't cover the fine details of art licensing, but you can get a good introduction to licensing by viewing the interview we did with licensing experts at theabundantartist.com/licensing.

BRINGING IT ALL TOGETHER

You can combine some of these business models together. The lines between gallery and independent artist are becoming more blurred all of the time. Many galleries are now preferring to work with artists who have an established following.

The Australian painter Hazel Dooney has a popular blog. From time to

time she writes on her blog about throwing gallerists out of her studio for pushing her to let them sell her work, even though she has expressly stated that she would prefer to sell independently. The gallery owners recognize that she has a valuable audience and would like to take advantage of that.

I know an artist in the American Midwest who has a deal with his gallery that states that whenever they sell one of his originals, they pass the buyer's contact information to him so he can thank the buyer directly. This forms a great relationship between gallery, collector, and artist, as everyone is transparent. In return, the artist agrees that any sales that come from that collector, including referrals to friends, are split with the gallery at the standard commission rate. This kind of deal is rare. Gallerists have traditionally been unwilling to share their contacts with the artist, but as the Internet allows collectors to deal directly with the artist themselves, I'm talking to more galleries who are embracing this openness between gallery, collector, and artist.

Many artists who show in galleries or sell originals on their own supplement income by doing commissions and selling prints. Even Andy Warhol did portraits (for $25,000 a pop).

The choice of how you want to sell your art largely doesn't matter. You can make money in various ways. What really matters is how you want to live your life. Different methods of making and selling art support different daily interactions. Commission work requires regular, clear communication with collectors, which can be fun if you have an outgoing personality and enjoy talking to people. Some artists go into deep studio hibernation mode and emerge only to sell their art a few times per year. These artists are probably best suited to working through galleries. Some artists love sharing personal stories and participating in conversation with the wider world, and are a natural fit for selling direct to collectors. One is not necessarily better than the other. You decide.

Once you know who your ideal collectors are, and you know how you want to sell your art, it's time to start linking those things together.

Consider selling art primarily through your own website, as you'll get to keep 100 percent of the proceeds. If you can't readily build a website, then you can pick any of the two-hundred-plus websites that sell original art online.

Many artists have asked me what will happen to their gallery relationships if they decide to sell directly from their own websites. Most galleries won't be comfortable with it. You will want to check your gallery contract and have a conversation with the gallery owner about it to find out how they feel. Some galleries want to control the entire sales experience.

If your gallery demands that you sell your work only through them or that they receive a commission from any work sold on your website, it's time to make an analysis and determine if that relationship is worth continuing. If the gallery is selling for you regularly and is bringing you substantial income, then it's probably worthwhile to concentrate on just using the Internet to build your brand and attract attention. If the gallery is not making money for you, then it's okay to walk away and stop working with them. You are in control of your own career. If a business relationship isn't working for you, it's up to you to make a change.

DISRUPTION IN THE WAYS ART IS SOLD

As you are considering how to sell your art, I want to give you an idea of where the online art world is going. While a small percentage of art sales happen online right now, the following will give you a good picture of how that might change over the next few years.

In 2010, Artsy.net, a venture-capital-funded start-up, won Tech-

Crunch's Rookie Disruptor award. This is an award given to companies that either invent new technology, or find a new application of existing technology, that disrupts an industry. Artsy has since received more than $7 million in investment cash and has art world heavyweights like Larry Gagosian on its board.

Part of the reason Artsy was able to raise so much money is due to its innovative technology called the Art Genome Project. If you're familiar with the way the company Pandora Radio recommends music, you'll understand the basics of Artsy's technology. They assign a handful of tags to each piece of art in their database. For example, Vermeer's *Girl with a Pearl Earring* is assigned the following tags: Dutch and Flemish, Iconic Works of Art History, Chiaroscuro, Eye Contact, Earring and Headscarf. Artsy takes it one step further by assigning each tag a value of one to one hundred, depending on how much of that particular attribute the painting has.

If you look at that painting on their website, they will show you a collection of images with similar attributes. Looking at *Girl with a Pearl Earring* brings up Frans Hals's *Portrait of a Gentleman*, Jan Steen's *Adolf and Catharina Croeser*, and Hendrick ter Brugghen's *Bagpipe Player*. The process of categorizing this art is assigned to a team of web developers. A team of professional art historians and curators with many years of experience oversees the data.

You can imagine how a system like this would enable people to discover art that they never would have seen before. You can search out your favorite art and find objects similar, giving you an easy way to fill out your collection with more items that match your taste.

Artsy's stated goal is to become the default place to collect, buy, and sell art. That's a big goal. But with technology like theirs, it's possible to imagine them achieving that goal.

Along with Artsy, a whole bunch of other art sales start-ups have

appeared, each with its own technology and strategic plans. Curator's Eye, 1stdibs, Masternet, Paddle8, Artspace (with more than $12 million in funding), and more. Tens of millions of dollars are being invested because wealthy investors believe that the way art is being bought and sold is ripe for massive change—"disruption" in tech language.

Amazon, the largest online retailer in the world, has entered the art sales space. eBay is heading back into it after two previous failed attempts. They have formed a formal partnership with Sotheby's. These are *big* companies that see *big* money in fine art. Sotheby's partnership with eBay is a rare example of the fine art world understanding how the Internet is affecting fine art sales.

In chapter 1, I outlined how the music industry failed to understand the power of file sharing. I believe the fine art industry is now in the same place the music industry was with Napster in the early 2000s. There are now dozens of examples of painters becoming "YouTube famous" by acquiring a huge following via YouTube and then making a living selling their art online directly to collectors via their own websites, without the support of galleries (or moving to major galleries only after becoming famous).

If Artsy wants to become the iTunes of fine art, you can imagine how disruptive it might become. So what lessons should you take away from the recent changes in the music industry? What opportunities is the Internet opening up, and what traditional bastions are taking a hit? It's early to tell, but here are my thoughts.

HOW THE WEB HAS DISRUPTED ART GALLERIES

According to First Research's *Art Dealers and Galleries Industry Profile*, in the United States roughly 20 percent of all art galleries have closed since

2007. Gallery owners will tell you that the Great Recession had a lot to do with that. Some gallery owners will also tell you that a growing number of collectors want to buy art directly from artists. They see the artist's name in the gallery and then they go home and Google that artist. They make direct contact and ask if they can buy the painting at a discount.

As a side note, I hope it goes without saying that an artist should never agree to this. The gallery took on the expense and risk of representing you. They deserve their commission. Not giving them that commission is cheating. If you want to continue having a relationship with your gallery, be sure to pay that gallery their commission.

But galleries are bringing this upon themselves. In various art gallery associations that I'm aware of, older gallerists are railing against the changes, insisting that no serious collectors are online.

In their less guarded moments, however, gallerists will also tell you that the Internet is playing a role in gallery closures. Instead of going out into retail shops, an ever-growing percentage of the population is doing online research to find out what they want to buy before they ever see it in person. Unfortunately, many galleries don't have websites, and many of the existing sites provide poor experiences or insufficient information for an online researcher to make an informed decision. This disintermediation of the salesperson is common across many industries, not just fine art.

Galleries going online

A handful of savvy art galleries are taking their business online. Xanadu Gallery in Scottsdale, Arizona, started an e-commerce section on its website several years ago. Any artist can apply to upload images of their work to xanadugallery.com and set a price for it. Xanadu has been

in business since 2001 and its clientele comes from all over the world. When one of its clients makes a purchase on the website, Xanadu pays the artist the full purchase amount and requests a 20 percent commission in return.

Artists will recognize this as a huge deviation from the norm for most art galleries. It's an unfortunate reality that most galleries are ignoring the opportunities of the Internet. If a gallery does have a website, it rarely has a comprehensive inventory of the gallery's art for sale, and even more rarely offers a true e-commerce experience. Xanadu recognizes that selling online is a different model than selling in person, and their 20 percent commission reflects that recognition.

Do people really buy original art from the Xanadu website? The website's very first sale was an $8,500 piece that sold sight-unseen to a couple in Georgia. Jason Horejs, Xanadu's owner, explains that every year, sales from his e-commerce site have grown a little bit to about 15 percent of his total sales.

Xanadu isn't the only gallery that has opened an e-commerce experience. Additional examples include ModernEden.com, Ugallery.com, SaatchiArt.com, Art-Mine.com (owned by Agora Gallery), and others. Some galleries have reported that the Internet makes up 50 percent or more of their sales.

Kim Larson from Modern Eden explained how the Internet has shaped her gallery's success. Kim and her husband, Bradley, started their gallery as a place to gather their own community of artists and hold shows. Their website was initially an afterthought. They didn't even put shows and exhibitions on the site for a year. That first exhibit generated their first online-only sale: a $3,000 painting by Sergio Lopez.

Since then, sales have increased dramatically, both in size and volume. The website has become an integral part of their business and

established Modern Eden as a solid midtier gallery. When I asked Kim what percentage of their business happens online, she told me there is no way to separate what sells online from what sells in the gallery space. People come to the website for info about the shows, come to the shows, and either buy something there, or buy something from the website after seeing it in the space. Either way, the Internet is playing a role in their sales. "It's just the way we do business now," she says. "People are so comfortable buying things online. I think it's just going to become even more so."

Most of the fine art industry is ignoring independent artists

Since 2010, more than $30 million has been invested in start-ups that sell original art like Artsy, Paddle8, Artspace, and others. Despite the cited examples of galleries doing a great job selling art online, the fine art world has, for the most part, missed the boat when it comes to innovative marketing and technology.

When Artsy first showed their concept idea and technology, the promise was that they would be able to help collectors find art according to their tastes, often matching collectors with obscure artists that they would otherwise never see.

The reality of Artsy is that the site includes art that is represented only in their partner galleries. This is just a tiny percentage of all art. There is no technological reason for Artsy to limit the artists they represent in this way. Artsy's board is led by art gallery insiders like Larry Gagosian and Dasha Zhukova, and their business partnerships with the galleries and fairs like Art Basel mean they must focus on pleasing these constituents.

When I reached out to Artsy to ask them about this, they were very

willing to talk about their curation process, but when I asked to speak to someone about why they refuse to list independent artists or artists outside of their partner galleries, they never connected me with anyone who could explain it, despite repeated attempts.

It could very well be that Artsy does become the iTunes of fine art. As more people become comfortable with buying art previewed only online rather than in person, Artsy's business will likely increase. As brick-and-mortar galleries continue to resist this trend, they are ceding ground to online galleries.

Bad actors

Just like in every industry, there are a handful of bad actors online. Some companies just want to make a quick buck at the artists' expense. I strongly recommend you look at partnering with companies that put the artists' interest at the forefront.

The normal commission for a retail brick-and-mortar gallery is 50 percent of the sale price. I have seen a growing trend of artist websites that want to take the same 50 percent commission. Websites just don't have the same overhead costs for commercial rent and storage that physical galleries have. I have a hard time justifying that 50 percent commission for an online gallery, especially when legitimate galleries like Xanadu charge only 20 percent for online sales.

There may be some exceptions to that rule. If an online-only gallery has an especially well-heeled clientele, with a strong track record of sales, and they provide exceptional support for you, then they might be worth that 50 percent commission. Certainly no online-only gallery is worth paying more than 50 percent.

The same applies to POD sites. The best ones, like Fine Art America

and Saatchi Art, both add a 30 percent fee on top of whatever price you set for your print. I would consider that to be the industry standard as of the time of this writing. Both sites have a huge customer base and a strong track record of sales. Other POD sites would do well to follow their lead and not charge artists exorbitant fees for selling prints.

A FINAL WORD

We have already introduced you to a handful of artists who have built successful independent careers, mostly outside of art galleries. I want to wrap up this chapter by reemphasizing that your career is in your hands. While this chapter has outlined some of the broader movements in the art market, it is not necessary to keep up on every nuance and change.

The overview in this chapter is meant to give you an introduction to the options that are out there and push you to look for partners that are forward-thinking and who have the artists' interest in mind. Over the next few chapters we will cover marketing principles that you can use, whatever kind of business you choose to have as an artist.

TELL STORIES AND SALES WILL HAPPEN

In previous chapters, we outlined some tools used for online research and talked a lot about the state of the art market in general. This is the chapter where I remind you that cool technology and market research tools are far less important than the kind of stories you tell. Stories are important. Stories matter. Stories sell art better than anything else does.

Many artists choose to skip researching their ideal collector or figuring out what kind of business they would like to have. Instead, they flounder for a while. They may even find some success. Many artists find themselves flipping back and forth between who they are marketing to, what they are trying to say, and how they want to sell art.

My friend Melissa Dinwiddie is a great example of this phenomenon in action. Starting in the late 1990s, Melissa built up a hugely successful ketubah business. A ketubah is a special type of Jewish wedding docu-

ment. It is considered an integral part of a traditional Jewish marriage and, in its most traditional form, outlines the rights and responsibilities of the groom in relation to the bride, though for more progressive couples, they're more akin to poetic wedding vows. They are often hand-lettered in elaborate calligraphy with beautiful illuminations. Melissa wanted to grow a business from her art, so she started selling her ketubah services to anyone who would pay her anything. Her first ketubah commission took her seventy hours and brought her $700. She could have made more working in a fast food restaurant!

While Henri Murger did emphasize the temporal nature of the Bohemian state of existence, it's absolutely true that most artists experience some time in that state. Melissa found herself trapped and unhappy in her ketubah business because the people that she was working with saw her as a commodity instead of a true artist. They valued her work, but only at about the same rate as a premade gift that was found in a hobby shop. These were not the kind of clients or collectors that she wanted to be interacting with on a daily basis. After just a few commissions, Melissa began to feel resentful, and even contemplated quitting the ketubah business altogether.

When your heart isn't in your business, your audience will know, and your customers will sense it. You will be hesitant and timid, or you will upset people during your interactions, and the money will be a constant struggle.

Melissa figured out she could make more money, and have a steadier income, if she streamlined her business and turned most of her ketubah designs into prints. For several years, she focused on growing her line of ketubah prints, and she was on track to bring in $100,000 in revenue when the recession hit, and Melissa's business tanked along with the rest of the economy.

She struggled for two years to rejuvenate the kind of sales she'd seen before the recession, but her heart wasn't in it. She realized she was burned out on creating art to please other people, never to please herself.

Melissa's business woes seemed like a disaster. Ultimately, though, the economic crash had a silver lining: it helped her see that she needed to get back to the creative joy she used to feel—the reason she'd gone into business as an artist in the first place! She intentionally refocused her art on the passion that she loves, and since that time, Melissa has created all kinds of art: abstract watercolor, mixed media pieces, and even the release of a music album. She's a true multipotentialite.

In chapter 2 I shared Melissa Dinwiddie's story about selling several pieces of art to some fellow conference attendees. They had gotten to know her and trusted her to suggest the best piece of art for them.

This is what happens when an artist builds trust with their audience. You can do the same thing with your audience in a variety of ways.

Most of the famous artworks in history are famous because of some story associated with that artist. The *Mona Lisa* was stolen from the Louvre. Damien Hirst went to the trouble of having a live shark fished out of the ocean, killed, and preserved in a giant tank of formaldehyde. Jeff Koons married a famous Italian pornographic actress and made a statue of the two of them. These are all stories from the fine art world that stick with you.

Think about walking around a museum and reading the little placards next to each piece that give you some historical context and perhaps a short paragraph about what the artist was doing with their life at the time. You need to give your audience the same context.

Jolie Guillebeau is a great example of an artist who puts her story and her values ahead of her business. After finishing art school, Jolie set out challenges for herself to decide how she could push her own artistic

boundaries, then publicly declared her goals to her friends and family. The stories she told as she shared her progress endeared her to her audience, and they rewarded her for her vulnerability with their wallets.

In 2009 Jolie let all of her friends and family know that she was going to make a series of new still-life paintings and e-mail images of the paintings to everyone who wanted to be included. She wanted to hone her still-life-painting skills and hold herself personally accountable. Jolie began e-mailing her initial list of about fifty friends and family the next day, and included a short two-paragraph story about why she created the piece. She priced her first painting at $1. She sold it.

On day two, she sold another for $2, and so on until she sold ninety-seven paintings in one hundred days. People were getting up at 4 a.m. so they could be the first person to grab her daily painting. For years, in her own words, Jolie had been "whining about how unhappy I was." Suddenly, she realized, "Oh my god. They're out there and they care."

Jolie didn't do any exceptionally crafty marketing. She's done several art projects that included a line of one hundred pieces, covering still life, plein air, encaustic, ceramics, and more. She just created art and let her audience know that it was happening and shared a little story about each piece. A daily e-mail from her recent cer contained this story.

We have a joke in our family, that if you do something once, it must be a tradition.

I love traditions. And many of my traditions involve mugs. Hot chocolate on Christmas Eve, coffee with soy milk at Sunday brunch, Yogi tea just before bed every night. Though technically, some of those are rituals, not traditions.

Come to think of it, if a tradition is passed down through gen-

erations, then I guess Mug Monday doesn't quite qualify. And since we're only on our second Mug Monday, it's not quite a ritual either.

But it will be.

And then she added a picture of the mug. I bought it immediately.

I *love* hot chocolate. Growing up in frigid, snowy Utah winters, there is nothing like a mug of hot chocolate after hours of sledding, and Jolie evoked that sense memory for me. I was already looking for an excuse to buy one of her pieces, so this was perfect.

Jolie's daily painting series were beneficial in other ways as well. In addition to building her writing skills, the series generated interest from potential art students, buyers of her higher-priced work, and led to speaking opportunities.

In 2014 I attended a Portland, Oregon, TEDx show, where Jolie was the featured artist. When you walked into the auditorium, the stage backdrop was a twenty-foot-high, fifty-foot-wide curtain made of individual six-by-six pieces of Plexiglas with Jolie's artwork on them, suspended from wires. There were one thousand pieces. The TEDx organizers had seen Jolie's one-hundred-piece projects and gave her an opportunity to display a full show in one place.

Speaking at the conference,

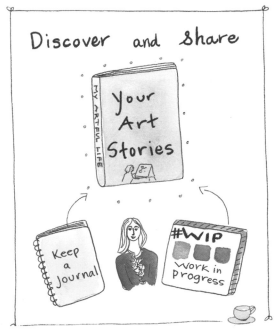

Jolie shared some of her own experiences in learning to create art one hundred pieces at a time, and talked about the power of vulnerability and the power of connecting with your audience.

When I tell Jolie's story as an example of what you can do to connect with your audience, many artists feel overwhelmed. They tell me things like, "I'm not a good writer" or "I don't have an audience and nobody wants to hear from me."

My response to that is usually, "You have to start somewhere." Jolie grew up in Hazel Green, Alabama, population twelve thousand. She took art classes in high school, but the art teacher wouldn't let her into the second-year art class because she wanted to save the seats for students who weren't academically proficient so they could potentially get art scholarships. Since Jolie did well in school, she was out. Because she didn't take more art classes, and because her family didn't encourage it, Jolie didn't major in art in college, but she did take art classes. The professors ignored her and told her not to come to class because they wanted to spend their time with the art majors.

Jolie didn't have the courage to get the training she needed as an artist until she was in her late twenties. She didn't have any special help or connections. She just started making art and sharing her story. The right people connected with her story and she built that audience one person at a time.

Every artist builds their story differently. Some artists do daily paintings with short stories like Jolie. Some artists hop from medium to medium like Melissa Dinwiddie, tying it all together with the force of their own personality. Some artists do it with video. Some do it with social media. Some do it with live painting.

Many artists tell me they don't know what to say about their art. They don't know how to talk without falling all over themselves or get-

ting tongue-tied. Whatever format you choose to share your story, there are some steps you can use to learn how to discover your own story and communicate it clearly.

Journal discovery. When you are creating art it can be very helpful to write about the experience of creating. Keeping a personal journal around your process can be very helpful. Writing down what you did and how you did it will help you reproduce new techniques as you discover them. The more important part, however, is the personal journey that you go on when you write about your art. Writing about your feelings, your sources of inspiration, the reasons you chose the colors, the fabric, the canvas—these things are important to help you understand your own work.

I see far too many artists start journaling and making the mistake of writing only about their technique. They have the where, what, and how, but they miss the why—and the why is where things become really intriguing. This is the place where story comes from, and the place where you can begin to help other people connect a little with your work and your process.

You may be tempted to skip the journaling process. It does interrupt the flow of creation, and it can bring up a great deal of self-doubt and self-criticism, but it's important to do. Many artists have told me that the journal discovery process has helped them discover new levels in their art that they didn't know they had. Quite often we find ourselves making the safe choice instead of the bold choice, and only through critical self-examination will we realize that we can do better.

These nuggets of process and personal insight become the seeds to compelling marketing content—blog posts, e-mail, and social media. You don't have to reveal as much about yourself as artists like Gwenn Seemel, but you need that human element in order to tell a compelling story.

Work-in-progress (WIP) pictures. I'm a giant nerd about behind the scenes documentaries and movie previews. I always insist that my wife and I go to the movies twenty minutes early so I can see all the previews. I've watched more than four hours of behind-the-scenes footage of *The Lord of the Rings* extras. I'm the guy that watches directors' commentaries and I love listening to annotated albums on Spotify. I can't get enough of it.

And there are people who *love* progress pictures. Love them. Seriously, they can't get enough of them. They're like movie previews and behind-the-scenes documentaries. Sharing a WIP shot on social networks or a series on your blog or e-mail list is one of the best ways to market your work online.

Besides acting as a preview of your work, WIP shots also help you document your own process. This means that in addition to your journaling, you have actual visible evidence of your process, which you can refer to later. I recommend taking a new picture with just your smartphone with every layer or every couple of hours that you work on a new piece.

Cover the bases to make your art worth more money. There are a handful of activities that by themselves don't make a story, but collectively help people understand who you are as an artist, and where you fit in the pantheon.

Sign it. Whether it's legible or not, your work should have some sort of signature that is consistent throughout all of your work. That way people always know it's yours.

Title it. There are too many works called *Untitled*. Your work should have a name. Even if it's *Blue Series #4*. Then at least people can specifically talk about your pieces. Smart artists give their work names that intrigue the collector, that give a way in without being too specific or prescriptive about what the viewer should take away.

Date it. Right next to your signature. Don't be suckered into thinking that collectors want only new stuff. When you're famous, people will want your earlier work, and they'll use it to explain your evolution as an artist. When you have a retrospective at a big fancy museum, this will be gold for your curators. If dating it makes you uncomfortable, do it in some sort of code. Then people can have fun cracking the code, which brings more attention, which raises the value of your work.

Number it. If you make multiples of any kind—open-edition or limited-edition prints, photographs, screen prints, or something else— you should number your series. Collectors expect to know which piece they got, and in the case of limited editions, they expect that the size of the collection doesn't change.

Explain it. Just like a gallery or auction catalog, you need at least a one- or two-sentence explanation of the work, a "way in" to understand or at least explore. Give collectors some way to discuss your work so they might talk to their friends about it.

Give context. This is where most artists fall down, I think. What is blogging but giving context to your art? How does

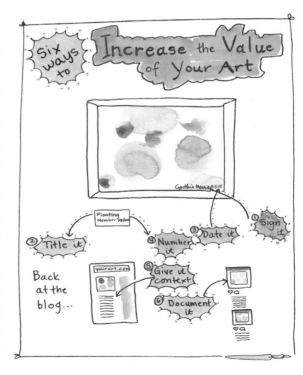

free culture play into Gwenn Seemel's work? You can read her blog posts on copyright to find out about how it might affect her work.

Doing these activities alone will help you build a story. I'm not talking about a made-up story that you add to the art, but the actual story of the art. What went into making it. The reason people might find it interesting. Good art doesn't sell itself.

"My art doesn't have a story." Someone said this to me in a response to a reader survey. It made me unbearably sad. Every piece of art has a story if it comes from your heart or soul and isn't just technique practice or mindless doodling. You are your art's story. You are the thing that matters when it comes to selling your art. If you say your art doesn't have a story, it's like saying that you don't have a story or that there is nothing interesting about you.

This is, quite frequently, the primary problem I run into when working with artists who want to sell their art. They don't know who they are and what they stand for, so they can't possibly know what their art is about or how to communicate it.

And you won't get anywhere until you figure that out.

Learn to write. Once you've covered the basics and you have done the internal work necessary to better understand your own art, it's time to learn to write. If you went to art school and hated your writing class, I sympathize, but they teach you to write for a reason. Writing is communicating, and you must communicate about your art.

You don't have to become a great writer, but you must learn to effectively communicate at least some of your ideas. The rest of this chapter is devoted to resources to help you acquire that skill.

The following suggestions are taken in part from a blog post written for us by Autumn Tompkins at ink well copy, who specializes in copywriting for creative people.

Describe your artwork as if you were talking to someone who couldn't see it.

Pretend the average person is blind. They can't see anything. Not even shadows. Just because they're blind doesn't mean they can't use their four other senses to feel your artwork.

Suppose you were trying to describe a painting you made of some stars. Instead of describing the colors of the stars, describe how the stars would feel, for example, like twinkling raindrops falling into the palm of your hand.

The average person will become strongly connected to artwork they can feel using their imagination.

Describe the mood of your artwork as well as the visual characteristics.

Mood is an internal and rather subjective emotional state. Grammatically speaking, mood is used to indicate modality. There are several types of grammatical moods including indicative, interrogatory, imperative, emphatic, subjunctive, injunctive, optative, and potential. As an artist, you'll want to grammatically describe the mood of your artwork using the indicative type. This type is used for factual statements and positive beliefs.

As you know, the visual characteristics of artwork are lines, colors, values, shapes, textures, space, and movement. To describe them, you must think beyond straight or curved, red or orange, light or dark, round

* If you have trouble with this, ask your friends to describe their feelings about your artwork using descriptive adjectives.

or square, striped or polka dot, shallow or deep, and small or large. Instead, you must talk about these characteristics using much more descriptive adjectives.

To describe the mood and visual characteristics to the average person, ask yourself these questions:

- How does its ambiance feel?
- What undertones does it evoke?
- How does its essence affect your spirit?

The average person will become enchanted with your artwork when you talk about its mood using descriptive adjectives.

Always mention the colors, but make sure you use words that describe the colors and their effect.

For example, green is the color of grass, the leaves of trees, and seaweed. Green represents growth and healing. Red is the color of blood, roses, and hot chili peppers. It's a very passionate color and red can mean anger or desire.

To articulate the depth of the color, use words such as *lustrous*, *shadowy*, *radiant*, *glossy*, and *saturated*.

The average person will see your artwork in a different light if you describe it using words that connect your artwork to the smell and feeling of everyday objects.

Put yourself in the mindset of the average person.

The average person knows little about art and your art-making process. For them, it all boils down to dollar bills.

The sad thing about the average person is that they earn money by doing things they don't love. They have a lot of bills to pay. They don't

have the luxury of being creative. They don't have a lot of money to spend on art.

But the great thing about the average person: They see money through the eyes of emotion. If they want something bad enough, they'll find a way to get money to buy what they want.

What you have to do is create that emotional connection between your artwork and the average person.

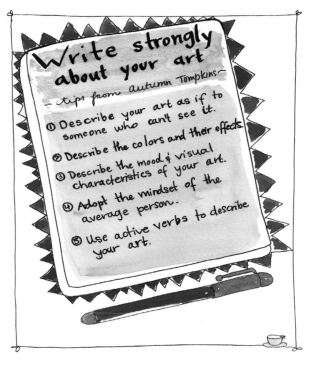

Write strongly about your art

— tips from autumn Tompkins —

① Describe your art as if to someone who can't see it.

② Describe the colors and their effects.

③ Describe the mood & visual characteristics of your art.

④ Adopt the mindset of the average person.

⑤ Use active verbs to describe your art.

The average person isn't looking for a landscape painting filled with farmland and barns. Their soul is yearning for a striking piece of artwork for their entranceway that'll greet visitors with a warm blast of dazzling sunlight that conjures their memories of the many summertimes they spent on grandpa's farm. Complete with the intoxicating aroma of a freshly cut hay field, and the glistening golden blades of hay.

The average person can feel artwork if it's vividly described, creating an unwavering emotional connection.

Art isn't passive. Use action words to describe it.

Richard Serra once said, "Drawing is a verb." He created a list of

the infinitives of eighty-four verbs including to roll, to crease, to fold, to store, etc. This shows that there are lots of possibilities when it comes to describing your artwork.

You need to find the right words to use. To determine which action words to use when describing your artwork to the average person, ask yourself these questions:

- What does the piece do?
 - Perhaps it charms like James Christensen's *The Royal Processional* or inspires like Michelangelo's Sistine Chapel ceiling.
- What will the average person do with it?
 - Perhaps they'll luxuriate in it.
- Does it make a statement?
 - Perhaps it creates a serene atmosphere.

The use of words to describe artwork is completely subjective, and artwork may mean different things to different people. However, with effort, imagination, and practice, you can give the average person a more lively and interesting experience while viewing your art.

The following from Lisa Baum, head of communications from the Global Art League, explains some additional steps you can take to tell your story as an artist.

Construct the elements of your story.

If you want to sell your work, one of the fundamental challenges you have is building a deep connection with your audience. By capturing their imagination, you can create this feeling of connection. Fortunately, there are a few simple tactics that can help you build up the stories around each of your pieces.

For landscapes, you have to situate the audience—and not just geographically. Many artists simply mention the town, village, or region, but by giving more information you're creating a deeper shared experience.

Some questions you will want to consider for your story:

- How did you arrive at this place?
- What drew you to that place in particular?
- How long did you stay there?
- What other activities did you do while you were there?
- Your own connection to a place is generally made up of the attitudes you have, drawn from the activities you did, the people you met and your general mood. How have you captured this in the painting?
- Do you know some human stories that bring the place alive?
- If you create cityscapes, how do you feel when you look at the buildings?
- They may be stone-cold indifferent monoliths in real life, but who lives in these buildings and what do they do?
- If there are any historical facts that you feel add a dimension to the scene then be sure to mention them in your story too.

For figurative pieces there is often a soul to describe, which can even make your job more difficult. Some questions you will want to consider for your story:

- Who or what is it that you've painted?
- Why did you paint this object or person?
- What did you learn from painting it?

- What feelings does this thing or person stir up inside of you?
- Does the painting show something of historical significance (even recent history)?
- What are the cultural connotations of this image?
- Does the image hold a personal significance to you?

There may be times that you struggle to come up with an actual "story," and that's okay. Perhaps you just thought that you'd found a particularly nice scene with a tree against a blue sky and you wanted to paint it. What is it about that tree that you like? Where were you walking? Did you have a reason to be there other than painting? What does the process of painting feel like for you?

These are the types of questions that can build up your story and create the shared experience of your artwork. Sometimes you may find that a painting is quite personal, and you might not want to share the answers to these questions with strangers. That's okay too. This is why it's important to practice your story ahead of your exhibition, so that you're comfortable with how you're going to tell the story to a potential buyer. There is never any need to share more information than you're comfortable with.

The monomyth

Standing in front of the class, I concentrated on breathing deeply through my belly like I had been taught. I thought about things like releasing my jaw and keeping my knees relaxed. I had been standing in front of the class for about three minutes. I was wearing my regular street clothes, and the class was just . . . watching me.

A litany of thoughts flew through my head. "Am I doing this right? My neck hurts. Why is Sally looking at me like I have something hanging from my nose? Oh, I hope I don't have something hanging from my nose." And on this went for what seemed like an eternity. Finally, about two minutes later, the teacher called out, "time." I took my place with the rest of the class and sat down.

When I was in acting school, we did an exercise where we had to simply stand in front of the class for five minutes. No talking. No acting—with gestures, facial expressions, or anything. Just stand in neutral position for five minutes. The idea was to teach us how interesting human beings are by themselves without any added effort.

I found that exercise one of the most profound things that I learned in theater school. Humans are inherently interesting. Watching classmate after classmate go through this, you could see the litany of thoughts happening on their faces and in their bodies, even when they were trying to remain calm.

I often think about this exercise when artists tell me they don't have anything to blog about, talk about in their e-mail newsletters, or share on social media. Artists often tell me they don't think they are that interesting. If a person just standing there can be interesting, I think an artist can certainly be interesting.

Joseph Campbell, the guy that came up with "follow your bliss," came up with a concept that I find very compelling—the Monomyth. Campbell said that most myths contain some common elements—heroes start out as lowly mortals, they receive some sort of call to adventure and divine assistance to get started, encounter obstacles along the way, go through a transformation, and return to where they started as a hero, changed for the better.

We all recognize this basic structure in many popular stories. Stories as old as Beowulf follow this structure, while new myths like *Star Wars* follow it as well. Luke Skywalker, a nobody on a remote planet, meets his call to adventure when messengers from heaven (R2D2 and Princess Leia) summon him to help in the battle. Luke meets with adversity, must learn to use the Force, suffers defeat and nearly death at the hands of Darth Vader, but comes out the other side stronger, wiser, and eventually victorious.

In the context of telling the story of your art, it's easiest to think of the Monomyth as a way to structure the story of you as an artist, and your art, to your collectors. If you can do this well, you will get and keep their attention.

Let's take a look at the story elements and see how they fit with your art. If you're already familiar with Campbell's work, you'll recognize that we have included only the bare bones of his story structure here, and that's okay. We're just shooting to help you understand how you can use this structure to explain your own story.

The artist's call to adventure

At some point in your life, you were called to be an artist. Perhaps you woke up one day and realized that your interest in drawing was more than a passing interest and you wanted to devote your life to it. Perhaps there are subjects you want to talk about in your art that are important. These are the things you want to use to introduce yourself to collectors.

Some art buyers want to know what inspires you to make art—what the meaning is behind what you do, and where it comes from. The origin story is exciting to them. While it might be rather mundane to you, I can

assure you it's not to them. Many people feel the calling to become artists, but only a few actually follow through on that calling—so why did you do it?

Who, or what, was your Princess Leia distress call? When did you realize that you needed to take action and become an artist? Gwenn Seemel's bio page on her website is a good example of how to do this well.

I am Gwenn Liberty Seemel. My father wanted to name me Liberty Bell Seemel—after the great Philadelphian E-flat chimer—but made the compromise when my mother pointed out that that particular ding-dong is, in fact, cracked.

I was raised part-time in San Francisco and part-time in a small village in France. In Brittany, I attended the same grammar school my mother did growing up, and I learned to play a mean game of boule bretonne for an eight year old. Eventually, my family settled in the United States, in Oregon, and, these past few years, I have stayed on.

Obstacles to making your art happen

People love a good underdog story. They love to hear about what happens when their heroes meet opposition. I firmly believe that a big part of the reason people love open studio events so much is that they get to see works in progress. They get to talk to the artists and hear about their artistic process.

All good stories include an obstacle to overcome. You might not have some great tragedy in your life, but every artist meets adversity and re-

sistance when it comes to creating their work. Generally, the deeper you delve as an artist, the harder it is to bring your work to life. Those difficulties are the very things that you should talk about in your content marketing efforts.

A few good examples of obstacles I've seen artists talk about overcoming are:

- dealing with health issues
- figuring out how to make a piece that was very technically challenging
- finding funding
- struggling to communicate what is really happening behind the art
- railing against a system that puts artists at a financial disadvantage

These are, of course, just a few ideas.

The mentor/ally

In every great story, the hero has an ally, mentor, or guide. Luke Skywalker had Yoda. Harry Potter had Dumbledore. You need the same thing for yourself. Who is in your corner? By sharing your own guides with your audience, you can help them as well.

If you don't have allies or guides, I recommend finding them. Surround yourself with positive people. Most areas have a local group dedicated to professional development for artists. They might be called an artist group, alliance, council, or something similar. Find local artist critique groups that inspire you to do better (as opposed to the ones that just tear one another down). Find an art-making mentor, and a business

mentor (I'll gladly volunteer).

You can usually find these groups just with a simple online search. If not, ask other local artists you know for a referral.

Going dark

Every artist sinks into the creative abyss to do battle with what Steven Pressfield calls Resistance. Sometimes you have to hide away in your studio to make something truly great. You'd rather be in the studio anyway, right? I go through periods where my artistic muse grabs ahold of me and drags me into the deep. A big year for this was 2011. I spent the last half of the year stuck in a morass of writing my first one-man show. I virtually stopped blogging. I didn't do any other shows or write anything else. It was all consuming.

For you, it might be going into the studio to work out an idea you've had and discovering that it was really technically challenging, or, more likely, something that forces you to confront a secret fear or internal obstacle. This requires wrestling with it for a while on your own, perhaps with the occasional help from your mentor, until you're able to bring forth the final piece, or pieces.

After you come out of that dark fertile period, though, you'll have plenty to talk about. The really brave artists will be rewarded if they share the things that truly matter. You will have a new piece of art to share or perhaps a new outlook on life. By reaching out to your collectors during and after these dark times, you will find that many of your collectors are not just collectors, but true fans and people who are willing to support you. A burden shared is a burden halved.

Abandoning the self to make the ask

When you emerge from the abyss of creativity, you will have a bright

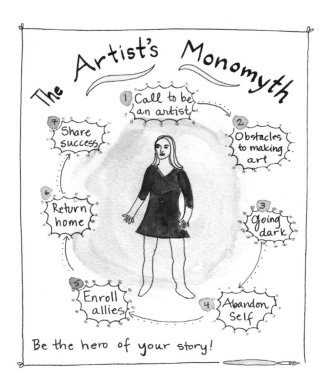

The Artist's Monomyth

1. Call to be an artist
2. Obstacles to making art
3. Going dark
4. Abandon Self
5. Enroll allies
6. Return home
7. Share success

Be the hero of your story!

shiny idea at some stage of completion (I know, an artist's work is never actually "done"). That's when you turn around and make the offering to whoever it is that has the power. Campbell calls this stage the Atonement. You recognize the being with the power—in the artist's case it could be the collector, the gallery owner, or the Internet at large—and make them an offering.

Whether you directly ask for the sale, or ask people to share a new piece you've created, or ask for gallery representation, you have to make

With a sales receipt or Barnes & Noble.com packing slip, a full refund in the original form of payment will be issued from any Barnes & Noble Booksellers store for returns of new and unread books, and unopened and undamaged music CDs, DVDs, vinyl records, electronics, toys/games and audio books made within 30 days of purchase from a Barnes & Noble Booksellers store or Barnes & Noble.com with the below exceptions:

Undamaged NOOKs purchased from any Barnes & Noble Booksellers store or from Barnes & Noble.com may be returned within 14 days when accompanied with a sales receipt or with a Barnes & Noble.com packing slip or may be exchanged within 30 days with a gift receipt.

A store credit for the purchase price will be issued (i) when a gift receipt is presented within 30 days of purchase, (ii) for all textbooks returns and exchanges, or (iii) when the original tender is PayPal.

Items purchased as part of a Buy One Get One or Buy Two, Get Third Free offer are available for exchange only, unless all items purchased as part of the offer are returned, in which case such items are available for a refund (in 30 days). Exchanges of the items sold at no cost are available only for items of equal or lesser value than the original cost of such item.

- Opened music CDs, DVDs, vinyl records, electronics, toys/games, and audio books may not be returned, and can be exchanged only for the same product and only if defective. NOOKs purchased from other retailers or sellers are returnable only to the retailer or seller from which they were purchased pursuant to such retailer's or seller's return policy. Magazines, newspapers, eBooks, digital downloads, and used books are not returnable or exchangeable. Defective NOOKs may be exchanged at the store in accordance with the applicable warranty.

Returns or exchanges will not be permitted (i) after 30 days or without receipt or (ii) for product not carried by Barnes & Noble.com, (iii) for purchases made with a check less than 7 days prior to the date of return.

On Your Next Visit to Cafe!!

Valid through 3/31/2022

Buy 1
Fresh Baked Cookie
Get 50% OFF a 2nd

Mix or Match any flavor

To redeem: Present this coupon in the Cafe.

K9NCF9Y

Buy 1 Fresh Baked Cookie Get 50% OFF a 2nd:
Valid for Fresh Baked cookies only.
1 redemption per coupon.
Items included are subject to change.
Ask Cafe cashier for details.

the offer or request. One of the primary mistakes that artists make in their marketing efforts is failing to "make the ask"—and then not letting themselves get down if the results aren't what they want.

Don't get in your own way by not making the ask.

Return and share your success

At the end of the story, the hero always returns home a changed person. He celebrates with his family and friends. You should do the same. Share your victories with your friends—whether it's a big sale, a new solo show, or just a great piece of finished art.

The principle of returning to report is necessary. I know that frequently after I go through an extraordinary journey I often don't realize how much I've grown until I try to communicate it with other people. Writing about it, thinking deeply about your experiences, is a way to learn at a deeper level.

BE THE HERO OF YOUR STORY

Keep in mind that the Monomyth is just one way of telling a story. There are some legitimate criticisms of Campbell's idea, but it works well as a way to structure a story. Putting yourself at the center of the story of your art is a powerful way to communicate the ideas of your art and connect with your readers.

Hopefully this chapter gives you some ideas on how to tell your story in a way that compels your fans and collectors to find out more about your work and hand over their cash. The rest of this book deals with the strategies and tactics of modern online marketing for artists.

I really can't emphasize enough how important it is to understand and grasp these first five chapters. Artists who fail to understand their audience, to develop the professional artist mindset, and learn to tell effective stories will find themselves facing not just the technical challenges of online tools, but the deafening silence of apathy to their noncompelling e-mails and tweets.

But if you can tell stories and connect with your ideal audience, you can make up for a lack of marketing expertise. Some of the most popular artists on the Internet have poor websites, but their audience doesn't care because they know that the artist cares about them as a person, fan, and collector.

SIX

BUILD A WEBSITE THAT SELLS

In the mid-1900s Gertrude Stein held private art salons in Paris. She invited her friends and friends of friends to come and look at art, read poetry, and discuss creativity and politics. She created an atmosphere that was exciting, intellectually challenging, and fun for everyone involved.

The artist salon is less popular now than it was in the post–World War II era, but I think that we can bring it back—with your website.

In this chapter we will cover what makes an artist website cause buyers to whip out their credit cards and plunk down some serious money for your art. Before we do that I want to address a couple of common misconceptions about artist websites in general.

Many artists and gallery owners continue to believe that people don't buy art online. This is patently untrue. If you still think this, then get it

out of your head. In the last few years, more than two hundred compaies have begun selling fine art online. If people weren't buying it, these companies wouldn't be selling it. Sotheby's and Christie's hold Internet-only auctions, where wealthy buyers are bidding millions of dollars for art they've seen only online.

I already mentioned Xanadu Gallery's $8,500 sale. The artist packaged and shipped the piece, and pocketed their commission, no problems. Perhaps the most compelling tell of how the art market is shifting online is Amazon.com's move into selling fine art. As of this writing, Amazon had more than 2,300 paintings listed at $10,000 or more.

The reality is that artists must have a website. It's absolutely necessary. If you want a gallery to represent you, they need to see that you have a body of work. If you want to sell to collectors at large, they need a way of viewing your work, and of paying you.

Many artists think they need thousands of dollars to build a good website. This just isn't true anymore. While a professional web designer will often charge $3,000 or more to design a site for you, there are myriad options for getting started at a much lower cost. We will explore some of those options in this chapter.

ART MALLS

Too many artists are spending their time building someone else's business.

In the United States, malls are a large building where they throw a bunch of stores together. Department stores combine with smaller clothing stores and everything starts to look the same. Malls are the home of

mass-produced, low-quality, overpriced stuff that nobody needs. Malls are the opposite of what people think of when they think of fine art.

There are lots of websites that act like malls. These art mall sites throw hundreds, even thousands, of artists together into one site. They make it easy to create the illusion that an artist has a "Web presence." When they upload all of their work to an art mall site, it makes artists feel like they are finally getting their work online. What you're really doing is creating more content for these sites to sell, with no investment on their part. You could be doing the same thing for yourself.

There are a number of reasons to have your own website instead of using an art mall. First, and foremost, you look like an amateur if you don't have your own website. It's so easy to get a website now that it should just be counted as part of the cost of doing business. More on how to do this later in this chapter.

You are an artist, not a commodity. If you are on one of these online art malls, you are one artist among thousands. Browsers will click right by all of your stuff because something flashier is right next to you. Even if you get featured as an artist of the day and have a few thousand people look at you, that attention is gone within a couple of hours.

You can build your fan base on your own site. When you are on someone else's website, you had better believe that they are benefitting more than you are. In professional marketing circles, this is known as digital sharecropping. When you share a page with a friend on Facebook, it links back to the art mall. With a little bit of work or a small investment of cash, you can build a site where people play directly with you, not with others.

Below are some of the primary reasons you should have your own website:

You have your own domain name. If your website is something like

YourName.ArtMall.com then you are leaving a lot of opportunities on the table. A real domain name (www.YourName.com) costs about $8 to $10. There's no reason to not have a custom URL. In addition to it looking more professional, you will do better in the search engines.

Be sure to pick a domain name that reflects who you are or a personal brand. YourName.com is great. If that's not available, then Your NameArtist.com or something similar. If you sell a specific type of art that is easily identifiable, then you might add that to your domain as well, e.g., YourNameWildlifeArtist.com or YourNamePetPortraits.com.

Control over your look and feel. If you are a dark and brooding artist, why are you displaying your work on a site with cheerful, happy arts and crafts? People need to see your work in a context that makes sense. In online mall sites, you get a limited set of looks, with a very limited ability to change them.

Last week I had a client e-mail me because her artist website was a mess. The company that she was with had made some changes to its website-building platform, which affected her website, and she didn't like the changes that were made. In addition, the company was keeping her mailing list hostage—she couldn't export her mailing list if she switched websites.

If you're using a template, then your site looks like hundreds or thousands of other websites. People expect artists to value creativity and originality. Your site should differentiate you enough to make you stand out. Also, most artist website templates already look like they were designed in 2000 with no updates since.

Flexibility. Even if the company just launched and they have every bell and whistle in their current templates, the Internet changes fast and you need to be able to adopt new technologies into your site as they come along. Most artist website companies shoehorn new features into their

sites in ways that are awkward and unwieldy. Also, some artist website companies try to be all things for their artists and they end up not doing anything very well.

You're taken seriously. If you are selling $2,000 original pieces of art, why do you have a website that looks like it cost $30? Your image has to match your market. Since most collectors are wealthy and educated, they are probably going to expect something a little more sophisticated.

Art malls usually don't give access to the HTML of your site. In order to make real customizations to your website, you need access to the HTML files. If you don't have access, you can't change borders, colors, sizes, and where page elements are placed. In addition, if you ever decide you want to move your website to another hosting provider or another company, you'll have to start over from scratch.

Hopefully I've convinced you to create your own website. The next section will show you how to break down the choices.

SELF-HOSTING VS. ARTIST WEBSITE SERVICES

Self-hosted sites are those where you pay for your own web hosting and build your site to your own specs. Many art schools teach artists the basics of HTML to enable them to do this. Free software like WordPress will make this process even easier.

There are dozens of companies that offer prepackaged artist websites. They are different from art malls in that they are dedicated sites with just your name and art on it. Understand that these companies are a stopgap for helping you get a site up if you can't build one yourself or can't afford to pay someone. There will be limitations on these sites in respect to what you can customize. Please note: Many artists use a blogging ser-

vice like Blogspot to get their first site up and running. Blogging services are a poor substitute for a website with a portfolio service.

What's right for you? That depends on your tech savviness and your budget.

- If you have less than $150 per year for a website and no technical skills, then you might want to simply use Blogspot or WordPress .com to get started. It's not ideal, but it's better than nothing.
- If you have a website budget of $300 to $500 per year and no time or technical skills to do it yourself, then you might consider an artist website service like Fine Art Studio Online or Shopify. They make prepackaged websites that are easy to set up and they offer phone support.
- If you have less than $300 and you feel comfortable doing things like adding attachments to e-mail and making simple HTML changes, then I would recommend building your own site with WordPress's self-hosted software. There are a number of tutorials online that will help you get started.
- If you have a bigger budget for a website, like more than $2,000, then have a professional design your site. You won't regret it. Stay away from designers who charge less than this. Experienced pros charge a living wage for their work.

A note about WordPress.com and self-hosted WordPress software. What's the difference? WordPress is a free software created by a community of software developers who wanted a website building tool that anyone could use. They released that software for free to the world and it has quickly become the single most common website software out there. Huge companies use it for their websites, and you can use it too.

WordPress.com, however, is a service run by the company Automattic. WordPress.com uses the WordPress software in a very limited way to create a free blog product with paid add-ons. You'll get only so far with a free WordPress.com site, as mentioned above.

Note that you will need a hosting service to use the full WordPress software. Hosting is simply renting space on a special kind of computer called a server that connects your website to the Internet. There are hundreds of companies that offer inexpensive hosting. For the budget conscious, I recommend Bluehost.com. If you're looking for rock-solid awesome hosting, I recommend WebSynthesis.com.

WHAT MAKES A GREAT ARTIST WEBSITE?

Whether you are building your site yourself, hiring a web designer, or using an artist website service, there are some important elements to which you should pay attention in order to get people to whip out that credit card.

Consider these important website design elements and common mistakes.

Readability

While most people don't actually do very much reading online, it is important that the limited amount of text on your website is legible. This is usually the most common mistake on artist websites. Readability is affected by text size, font, and color.

Text size. Looking at a screen already causes a strain on the eyes so don't make the text so small that a person is forced to squint or lean in to see it. On the other hand, the size of the text shouldn't be overly large ei-

ther, forcing users to continually scroll to read everything. For the main content of a website, font size should be between twelve and sixteen.

Font. There are thousands of fun fonts available to designers and there is nothing wrong with using them in an effort to make a website stand out, but tread with caution. Some fonts look terrible if they're too large, too small, bolded, or italicized, which contributes to poor readability. As a general rule, a website shouldn't have more than two different fonts in its design as a lack of consistency can be off-putting. Fonts can also set the tone of your website, so make sure to pick fonts that are appropriate to how you want to present yourself and your work.

Color. While unique color combinations may work well in an artistic setting, it doesn't always work so well for a website. Not only can odd combinations make a site look amateurish, but it can also make it difficult to read. Avoid light colors on dark backgrounds, and keep all of your body text the same color. Nothing looks more garish than websites where each word is a different color.

Layout design

The key to a great artist website in any avenue is simplicity, and a focus on the art itself. A common misconception is that simplicity = boring, but it doesn't. There's a reason why the foundation of every website is based on the same simple format—a header, a main content body with a sidebar, and a footer—and that's because it works. More ambitious designers are able to forsake this format or put their own unique twist on it, but for those new to web design, following this format will guarantee that each page is uniform and keeps the content well organized. Additionally, this type of layout designates an area for the navigation (either in the header or sidebar) which should always be concise, clearly visible, kept to a few basic links, and easily distinguishable.

Cluttered pages

Even with a simple layout, sites can suffer from too much clutter. Lots of images (outside of a designated art gallery page) or media files distract from the content, can make a site look unprofessional, and also add to the site's loading time for some visitors, which can cause them to lose interest and click away.

In the WordPress platform, it's tempting to include on your site some of the hundreds of plug-ins and widgets available to users, but these can do more harm than good, especially if you have no knowledge of basic HTML and CSS, which a lot of them require in order to be used properly. To keep a site looking clean and sophisticated, use any distracting elements—such as overly large or small images, videos, animated GIFs, plug-ins, etc.—in moderation.

Browser/device incompatibility

Not all browsers are created equal, and while your website may look great in the personal browser of your choice, it could be completely altered in another browser. Test the site in all the commonly used web browsers. It's also important to remember that more people are viewing websites through their tablets and smartphones, so having a design that's compatible with various screen resolutions is also important. Screenfly allows designers to plug their site in and see how it looks on some of the major devices out on the market, and while it's hard for newbie designers to make a site look perfect for every device, visitors shouldn't have to horizontally scroll (unless it's been designed that way) on your website.

Avoid Flash image galleries and landing pages. The most common smartphones and tablets don't recognize Flash pages.

General rules of thumb

- All text content should be checked for proper spelling and grammar.
- Links should always stand out; refrain from underlining or random font color changes on words that are not links to avoid confusion.
- Permalinks—links to pages that aren't supposed to change—should be checked regularly to ensure they aren't leading to a page that no longer exists or is no longer relevant.
- Visitors should always have a way to contact you, especially if your site is business-oriented. Make sure your contact information is easy to find. Consider placing it on your contact page as well as in the footer of your site.

Now that we're past the basics, let's dive into some of the things that will really take your site to the next level.

How do we incorporate your Uniquity (see chapter 3) into your website? Consider your target collector. As you are writing your About page, think about the things your target collectors have told you they like about your art. Use the language and modes of expression that your target collectors use. Avoid overly academic, trite artist statements that sound like they were written in a graduate school course on writing (or by an artist statement generator on the Internet). Clear, simple communication that the average person can understand is far better than trying to sound smart. You connection with your audience will be much more effective.

Make sure your personality shines through on your artist website. There are a variety of ways that you can do this. Include a professional headshot. The best headshots capture your personality instead of making you look "professional" (i.e., boring). Then, include some pictures of you having fun. Perhaps in your studio, laughing with friends or with

your pets. People love to see behind the scenes of the artist's work.

Artists Kelly Rae Roberts and Matt Richards have beautifully made videos that explain who they are, what they care about in their lives and their art, and which are short enough that people will actually watch them. You can see those videos at http://kellyraeroberts.com/about and https://vimeo.com/71230329.

YOUR IMAGE GALLERIES

Many artists are under the impression that just putting their images on their website is enough for people to get excited about them. There are a few details that need to be addressed in order for people to be able to easily see your images, and for search engines and social media to effectively index and share your work.

It's good to have a portfolio page where the website visitor can see thumbnails of ten to twenty pieces of your work on one page. Each image should link to a new page with a larger version of that image on it, with a description and purchase instructions.

Use descriptive image and page titles

Example: "Ancient Teapot Still Life." When you take pictures or scan images, digital cameras and scanners default to numbers when saving the images with a title. Then you get file names like Picture 0778698u. When you upload an image to a website that image gets its own digital address (the URL). This one might be yourname.com/Picture_0778698u if you left it as the default name.

The problem with this is that search engines read image URLs to get

a clue as to what the image is about. So what I would do is change the image name to "Ancient Teapot Still Life." Now the Search Engine sees yourname.com/uploads/ancient-teapot-still-life.jpg. There is descriptive text in that URL that the search engine can now read.

Set alt attributes

An alt attribute is a line of text that describes an image. They aren't displayed on the website but are in the website code and show up in search engines, web browsers, and other web software. Alt attributes were developed as a way to help web browsers like Firefox or Internet Explorer display text substitutes for images when they couldn't display the image. Search engines now use alt attributes as another way to find out what the image is about and how relevant the image is to a search.

Your alt attributes should be simple and descriptive. For example, for *Grateful*, an oil painting on canvas, I labeled the alt attribute as "Grateful Oil Painting on Canvas." You can view alt attributes by viewing the Web page source codes. Alt attributes are usually set in Photoshop or whatever image editing software you use to prepare your images for the Web.

Common website systems like WordPress or Blogger al. alt attributes easily. If you are using something else, then the HTML tags are:

Write on-page descriptions

Search engines like Google have also indicated that they are using on-page elements to find keywords that help with searchability.

For example, if you have a paragraph-long story on the page where your art appears, you could say this:

"Shot into the setting sun, then turned dark and menacing as I worked on it on the computer. The image was shot at *Hyde Park in Chicago in Spring*. I manipulated the *shadows* using Photoshop, deepening the blacks and dimming the colors. I wanted to evoke a *Sleepy Hollow*–esque feel from the *tree*, and the *setting sun* brings a strong sense of doom."

Those italicized words could be keywords people are searching for, so including as many descriptive words as you can is a bonus to you, because it means that telling the story of your painting, sculpture, or whatever actually helps you sell it. But don't italicize entire paragraphs, because that just looks dumb.

Social sharing buttons

Most blog posts have buttons that enable you to share the blog post on Facebook, Twitter, and other social networks. In its simplest form, social sharing is the act of taking a link and putting it on another website for your friends to see.

In addition to the big sites that everybody knows like Facebook, Twitter, Pinterest, and Google+, there are hundreds of smaller sites that fit specific niches. Some of these may be interesting to you, depending on your style of art.

So adding these buttons to your site will give you an opportunity to have people referred to your site. There are a few things you can do, however, to give your work a better shot at getting in front of the right audience.

Experiment with adding Like, Pin, +1, and Tweet buttons to each of your individual image pages. Each of your pieces of art should have its own page with a description and purchase info, along with these social sharing buttons. Find some sites where your target collector is

hanging out, and if that site has a recognized share button, add it to your site.

Just by putting these buttons on your site you are inviting people to make a sales pitch for you. You can even take that one step further by asking your readers to share a blog post or a particular piece of art. You can e-mail friends and ask them to bookmark something for you. You can also ask your followers on Twitter, Facebook, or other popular networks to share your stuff.

If you are an active contributor in a community, people will begin to know, like, and trust you. They'll be more likely to retweet, bookmark, or pin your stuff if they know you. Comment on other people's content. Share really good things you find. As you make friends you'll see more success. We will talk more about building a following on social media sites in chapter 8.

A note about copyright

Many artists come to me with concerns about having their work stolen if they put it online. The truth is that this will occasionally happen. You can take steps to make it difficult—upload images that are only 72 dpi, use a small watermark, and keep dimensions around 500 pixels wide—but a determined person will find ways to steal your work if they really want to do so.

You can take someone to court, but if, like most artists, you don't have enough money to hire a lawyer, recognize that being well-known online can be insurance against being ripped off.

In late 2013, it came to light that wholesaler Cody Foster had allegedly stolen a design from Lisa Congdon. The story was picked up initially by BoingBoing.net and other popular blogs; it spread like wildfire via

social media, which made it get picked up by the *Los Angeles Times* and other news outlets, which led to Cody Foster's entire product line being dropped by Anthropologie, West Elm, and other retailers.

If an artist is paying attention and rallies their social networks to spread the word about the theft, companies that steal their work will get hammered via social media. I have seen at least a dozen stories like this over the past five years. It's become so common that business schools are now using stories like this in classrooms to teach young executives what happens when companies try to steal.

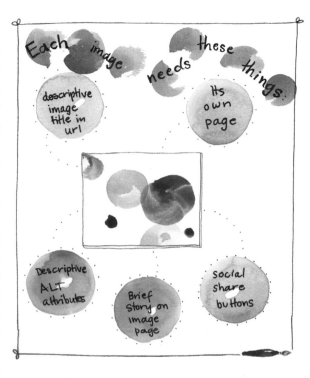

Each image needs these things:
- descriptive image title in url
- Its own page
- Descriptive ALT attributes
- Brief Story on Image page
- social share buttons

E-COMMERCE

My last piece of advice for your website is to use e-commerce. Sell your art directly from your own website. Unless you have a gallery that is just selling the heck out of your work and bringing you tons of money, I think every artist should use e-commerce. It just makes the entire payment process easier. Some artists try to pass off a "payment instructions" page

as good enough. It's not, I promise. As consumers, we have become conditioned to see things we want online, whip out a credit card, and punch in the number without having to make a phone call or send an e-mail.

Every step that you make someone go through before they buy something reduces the likelihood of them buying it. Think about when you're at the store. You might see a fun mug or shirt and think about buying it. If for some reason you can't find the price tag or the line is too long, you just might leave the item where it is and walk out of the store. It's the same process for your website. I am certain you will see more sales by adding e-commerce functionality to your website, and it's not that hard to do it.

Though it's the most intimidating part of building a website, the bulk of the challenge is that there are so many options to compare. I have broken these down to give you some specific suggestions.

Buy buttons

Ideal for artists without a variety of different items to sell, and technophobes.

Start with a basic working website. Then, I suggest you sign up with PayPal. PayPal will provide web code for you to copy and paste to your site, which will display a "Buy" button to take your customer to PayPal for the purchase.

Buy buttons are quick and easy to integrate into your website. Plus, the actual credit card transaction happens on a third-party server so you don't have to worry about having to up your website security to protect this sensitive information.

Open source shopping cart software + SSL certificate

Ideal for artists with a variety of different items to sell, who can handle step-by-step technical instruction and who have some time.

Start with a clean slate, just a domain name and web host all ready to go. Then, choose your free, open source shopping cart software. I recommend OpenCart. If you're using WordPress, I recommend Woo-Commerce as a shopping cart plug-in.

Now check to see if your web host provides an automatic install. For instance, with Blue Host hosting, when I log in to my account and go to my management dashboard (called C-Panel in this case), there is an icon for "Simple Scripts" listed. When I click on this, I see that it gives me OpenCart as an option of something I can auto-install.

If you're certain your hosting doesn't provide anything like this, you can download the latest version of the software from the OpenCart website and follow their instructions on how to install the files on your website. If you run into trouble, don't hesitate to search Google or You-Tube for more detailed info on how to complete the installation.

Once the software is installed, you sign in to the admin space (www .yoursite.com/admin) and configure the store as you please. Next, log back in to your web hosting account and purchase an SSL certificate. Follow the instructions for enabling the special URL on your checkout pages.

The shopping cart software allows you to sort and display your products in a slick, organized manner. Checkout and the actual credit card transaction take place on your site, within the rest of your site's layout, which is perceived as the most professional integration possible.

Hosted shopping cart software + SSL certificate

Ideal for artists with a variety of different items to sell, who are technophobes, who have some money.

Start with just your domain name; you haven't purchased web hosting yet. Then, choose your hosted shopping cart software. I recommend Shopify or Bigcommerce.

Review the plans they offer and sign up on their website. Once signed up, you can sign in to your admin space and configure the store as you please. Next, visit your new store website to see that checkout pages (where credit card information will be entered) has "https://" in the address bar. If not, find where on the site you can buy an SSL certificate and follow the instructions to have it installed.

The shopping cart software allows you to sort and display your products in a slick, organized manner. Just like the open source integrations previously mentioned, checkout and the actual credit card transaction take place on your site, within the rest of your site's layout, which is perceived as the most professional integration possible. Since the software and web hosting are bundled, you don't have to mess around with an installation—it is automatically installed for you. Also, some hosted shopping cart software carries the extra weight of the security burden by providing a built-in SSL certificate from the get-go.

Noteworthy: Shopping cart software of any kind (open source or hosted) will require a payment gateway and a merchant bank account. For those starting out, the easiest payment gateway plus merchant bank account is PayPal (it does both). As your store grows, however, it's worthwhile to look into options with fewer restrictions and lower fees. A Google search is the best place to start.

BEFORE BUILDING YOUR SITE

Consider sketching your website before you ever start building it. Handing a sketch to a web designer will enable them to just build what you want, or at least ask the right questions. Since you're both visual communicators this is a great way to start your site. If you are building your site yourself, sketching it out beforehand is a great way to keep yourself from getting lost in themes and templates. Be sure refer to the notes you took from the artist websites and templates you looked at while you were researching other artists online.

Prepare a website checklist

Before you build:

- Research your online competitors.
- Find at least 20 to 30 artists whose work is similar to yours. What works on their sites? What's doesn't?
- How can you stand out from other artists? What is your brand? What is your Uniquity?
- Self hosting vs. artist website services
 - Self-hosted sites are those where you pay for your own hosting and build your site to your own specs. Many art schools teach artists the basics of HTML to enable them to do this. Free software like WordPress will make this process easier.
 - There are dozens of artist website services that offer artist websites. Understand that these companies are a stopgap for helping you get a site up if you can't build one yourself or can't afford to pay someone.

If you're building your own site, sign up for the best hosting you can afford. We recommend Bluehost (for cheap, shared hosting) or Synthesis (for rock solid hosting).

Have your own domain name, such as JaneDoe.com or JaneDoeArtist.com. Subdomains like yourname.blogspot.com look unprofessional.

If you're building the site yourself, there are some great resources for design inspiration.

- Premade themes: There are literally thousands of great themes out there. TheAbundantArtist.com has a constantly updated list of some of the ones that I've used and are proven stable, and you can also look at various theme designers for lists of additional themes.
- Want to find some great icons, buttons, and other design elements to incorporate into your designs? I recommend checking out ShutterStock.com, Stock.Adobe.com, or iStockPhoto.com.

Design

After researching, sketch out what you'd like your website to look like. Literally. Bust out the sketchbook and draw it out. Keep it simple—design and navigation should be focused on your art.

Take that design to your web designer, or look for a theme that closely resembles your ideal design.

Include the following pages:

- **Home page.** Feature your very best work in large format, include a newsletter opt-in, and a call to action (tell the site visitor which art is for sale, or point them to your gallery representation).

- **About.** Your About page should first be about your audience, not you. Welcome them and give them an idea of what to expect from you and your art. Include your artist statement and resume, but put it below the main About section, or in a separate drop-down page.
- **Image galleries.**
 - Large, sharable images—shoot for about 500 pixels wide.
 - File resolution set to 72 dpi or ppi.
 - Each image has its own URL on your site? Lightboxes are nice, but the individual images in a slideshow aren't sharable.
 - Label all of your work with a title, description, and a one- to two-paragraph history or story on the page.
- **Blog.** Use your blog to tell the epic story of your art, make collectors swoon, and encourage sharing. Be fierce, engaging, and fun. Whatever fits your personal brand.

Avoid the following:

- **Auto-playing music.** No music when your site loads—this is just annoying. There are few things that will make someone click away faster.
- **Mouse effects.** Don't use scripts that turn the user's mouse into a tiger or a paintbrush.
- **Flash pages.** Flash-loading pages went away in the early 2000s, and Apple devices like iPhones and iPads and many Android products don't support Flash.
- **IFrames.** A lot of artists use IFrames to make their blog or other page appear on their website. IFrames break the page, cause problems with search engines, and usually don't look good.

Very Important: Break up your text with formatting. Use size 12–14 font. People rarely read on the Internet, and when they do they pay a lot more attention when you use **bold text** or *italics* to highlight the most important words. Try not to have more than 4 lines in a paragraph and use subtitle callouts like < h2 > in your html.

- **Disabling back buttons.** You should allow basic browser functionality unless you know exactly what you're doing.
- **Third-party advertising.** Your artist website is about you and your art. Third-party ads distract from your art, and they won't bring you much revenue unless you have a ton of traffic.
- **Curate images.** Don't show every piece of art you've ever created.
- **Keep it simple.** No background images unless it's your art.

Offer e-commerce unless you have a gallery that sells a lot of your work, and be sure to include terms and refund policies. Make sure your contact info is prominent and easy to find.

Setting up a website for your art might seem like a lot of work, but if you take the time to do it right, your website can be an always-on salesperson for your work. There's no better feeling than waking up to see orders rolling in via your website.

BUILD YOUR MOST VALUABLE BUSINESS ASSET

YOUR MAILING LIST

Many artists ask me if they have to blog. They have no idea what to blog about, they don't read blogs, and they don't want to blog. That's fine. You don't have to blog. But read this chapter. If you still don't want to maintain an artist blog, then don't—but you should at least be informed about the benefits of blogging.

Your blog is like pulling an intimate group of friends into a side room and having a longer, more in-depth conversation. A blog is your chance to sound off in-depth about topics that matter to you. Many artists make the mistake of thinking that a blog is just a place to show their latest completed pieces or work in progress. This is a mistake. Your blog should be about more than your art. People want to know about the artist—what

makes them tick? What is their process like? What do they care about? Some people even want to know about your politics and your causes.

In the early days of the Internet, Web-savvy people wanted a way of discussing long-form topics. Forums and message boards weren't quite right. They were a communal space. So online journals were created, and called web logs (now shortened to blogs). These original journals were ways for early technology pioneers to share their thoughts on a variety of topics. Many early bloggers were advocates of open source software, neutral paths through the Internet, and other wonky topics— but these early bloggers formed the way that our Internet is shaped today. They found one another through message boards, ICQ (an early messaging app), and then continued long conversations on blogs.

Today, many industries are moved and shaped by blogs. Technology isn't the only one. Fashion is heavily influenced by Tumblr, a blogging platform. Mothers around the world unite through mommy blogging, and have created a billion-dollar cottage industry whose recommendations make big companies go to great lengths to court. Major news stories are now often broken by bloggers.

If you can think of an artist blog not so much as just a way of journaling, and not merely as a means of promotion, but as a means of participating in a wider conversation about the topics you care about, then blogging becomes very powerful.

If you care deeply about the art world and the direction that it's heading, then your blog is a place where you can express those thoughts. If you have a particular charity or cause you support, your blog is a great place to talk in-depth about your passion, highlight those you admire, and convince others why they should care.

When you post content to your blog that highlights your passion and your story, people are drawn to that, and are more likely to share it with

their friends, thus growing your word-of-mouth cachet. In addition, search engines love blogs. Any website with regularly updated content tells search engines that this is a website that is relevant now, instead of weeks or months ago.

CONTENT MARKETING

Now is a good time to introduce you to the concept of content marketing. This was originally a buzzword created to encapsulate marketing practices that included creating blog posts, social media, videos, and other content that would be used to attract people to your site. It has now become a codified term used by marketing professionals, and there are even professional content marketing organizations.

All you really need to know is that content marketing (sometimes called inbound marketing) is a way of turning your art into Web content that markets itself for you, in perpetuity.

It used to be that sales people were the primary drivers of art sales. You walked into a gallery and a salesperson talked to you about the art, gave you all of the information that you required, and then they pressured you into buying something.

Now we are experiencing a fundamental shift in the way that all sales take place. When I worked as a salesperson, I sold a variety of items like cell phones, marketing services, and software. People frequently told me they wanted to do some research on their own before they were willing to make a purchase. Because information is freely available online, the salesperson frequently gets taken out of the process and the customer just buys directly from whoever offers the best information they find online.

Collectors can, and do, research an artist before they make a purchase. They can use search engines and social media to find an artist who matches their living room or corporate office. They can find an artist to draw their tattoo, create a stencil for their walls, or any other kind of art.

The question is, when people go looking for art, will you be at the top of their mind? How else will your art be found? Content marketing is one way to ensure this happens.

Quite frequently, when people buy art, they're buying the artist. They want to know your story, what inspires you to create, how you did it, and what you are working on next. As an artist, you already have a vision. You at least have an intuitive sense of why you create. If you work in a series, even better: that gives you a story to tell. Gwenn Seemel is great at content marketing. Her series *Crime Against Nature* depicts the interesting variations on gender roles that nature shows.

"For all my investigating and exploring, I still couldn't control whether or not I can have children, but I could decide to have a children's book instead. So I did. Crime Against Nature is this book and it's also a series that I am exhibiting as a version of the text that viewers can wander through as they read. Whatever the format, book or show, Crime Against Nature is meant for the kid in all of us: the person who hasn't yet felt the pressure to conform, the one who still sees the infinite possibilities of being," says Seemel on her website.

Gwenn has published her series of paintings not just as paintings, but also as a book, a series of blog posts, some great videos, a live showing, and more. Even though she might not say this about herself, Gwenn is a skilled storyteller. She knows how to communicate her point of view through modern tools. Remember, you are more interesting than you really think you are.

HOW TO CREATE AN ARTIST BLOG THAT
MAKES COLLECTORS SWOON

Some artist blogs attract hundreds of comments, shares, and tons of attention for the artist. Other artist blogs languish in obscurity. Why? Previously, I outlined how important it is to build content that attracts collectors to your work. The biggest reason most artist blogs languish is this: no one ever told them how to build an effective blog, so they're boring. Here's what you need to start to build a successful blog.

A focus on the ideal collector

One of the biggest mistakes I see art bloggers make is doing a lot of writing about their own pieces, art theory, art history, and specific painting techniques. This is fine if you are a teacher and your audience is other artists. If you are an art collector, however, you may not have as much of an interest toward in-depth tutorials on color theory.

Think about who your ideal collectors are. What do they like to read? What are they interested in? Why do they like art? Keep those things in mind when you are creating content. I know a number of artists who lead workshops as a way of generating interest in their own art. They publish instructional videos and how-to content that gets people interested. The key here is not to go into too much detail, or you lose them. Give them just enough to keep it interesting.

For most artists, teaching techniques might not be very effective. You'll need to focus on what the collector is interested in, which is usually the things that artists take for granted—things like your inspiration for your art, the reasons you make art, and the subjects that you choose.

Another great artist blogger is Kelly Rae Roberts. Kelly Rae fre-

quently discusses the need for positive messages in life. Her mixed-media collage work is full of kindly words, affirmations, and inspirational quotes. Kelly Rae uses her blog to inspire people to perform "kindness missions"—random acts of kindness for their neighbors. This kind of passion gives an artist blog variety and a "way in" to understand the art and the artist.

Infuse your content with artistic passion

You should be approaching your marketing content with the same zeal and passion you approach your art. There's nothing worse than seeing an artist whose work I really admire, clicking through to their website, and seeing a boring, stale, bland representation of that artist. As an artist, *you* are your brand. Like it or not, who you are is inextricably linked to how people perceive your art. You probably heard this from your art teacher in college: stop playing it safe! It doesn't work in your art, and it doesn't work in your marketing either.

If you are a bleeding heart liberal, let that come out in your art and in the way that you communicate. If you are a far-right conservative Tea Party activist, take that stand and be that person! If you are a sweet stay-at-home mother, be that person! Too many artists tell me they don't know what to say on their blog or in their marketing content, but I can ask them a few questions and get them talking for days.

My opinion is that 90 percent of the artists who don't know what to say are *stifling* what they truly want to say! This serves no one. Your marketing content should be an extension of your artistic voice. You may be wondering how you can write for your audience when you also need to put yourself into your content. The key is to talk about the things you want to talk about, but think about how it will be received by your target

collector. This is the first step toward gathering a tribe of people around you who will be passionate about you and your art.

By putting yourself in your content, your audience will identify with you and with your content, building a solid relationship for the long term!

Take a stand with pillar content

In Internet marketing parlance, pillar content refers to the content that is the core of your blog. For most big-time bloggers, their first three to five blog posts are what make up their pillar content. Generally, these posts are two to three times longer than their standard blog posts, because they are packed full of content. Quite often they are instructional in nature, and they are about the core topic of the blog.

For artists, this is going to consist of two things: your art, and your point of view. If, like Gwenn Seemel, you are interested in the way animals deviate from human expectations of gender norms, then write blog posts exploring those topics. Create videos where you talk about these things. Bring experts on animal sexual activity to your blog and interview them or quote them. Make it about more than just selling your art—make it about expressing the ideas of your art in as many ways as possible.

Use great pictures of your art

You would think it goes without saying, but yes, you need professional, high-quality images of your art. This is an absolute necessity when blogging and selling your art online. There are too many other artists out there doing this well. If you have crappy images, your work won't sell, and when it does, collectors might feel like they didn't get what they thought they were buying. Be sure to include pictures of your art in every

blog post. Even if that particular post isn't necessarily about your art, including a picture of your art is a great way to show off without having to constantly talk about how great you are.

IT'S ALL IN THE TIMING AND PROMOTION

There's a lot of advice out there that says you should blog daily, weekly, or three times per week. The truth is that while blogging on a schedule works for helping your readers know when you'll have new content, it's not absolutely a necessity. It's just one more tactic. If you can blog regularly, it will definitely help. But the thing that will grow your blog faster than blogging daily is promoting your content.

I'm not just talking about sharing your content on Facebook and Twitter. There are literally hundreds of places you can post your content online. Here are a few good ways to promote your blog posts after publishing them.

- Share on Facebook, Twitter, Pinterest, Instagram, StumbleUpon, and other social networks—experiment to see which ones work well for your site.
- Make friends with other artists and bloggers. Help them share their content and ask them to share yours.
- Find web forums where people talk about subjects related to your art, and share your blog posts there as appropriate.
- Occasionally e-mail your blog posts to local reporters when they're relevant—this works especially well if you learn how to pitch interviews and stories.
- Participate on other blogs by leaving comments, and then link back to your own blog posts.

E-mail is extremely important

Don't focus on building blog subscribers—focus on gaining e-mail subscribers. Sharing your blog posts to your readers via e-mail is probably the most effective way to make sure they come back. Also, once you have their e-mail address, you can let them know you have new art for sale, which is the end goal after all! Remember to use a professional e-mail marketing tool (I often recommend getting started with MailChimp.com), ask people to opt-in, develop a lead magnet (which we will talk about later in this chapter), and then experiment to see what works.

More on promotion and sharing your blog posts

Internet marketing professionals are big fans of the phrase "content is king." This means that high-quality content created for a specific audience does a better job of ranking in search engines and being shared on social networks than content that is intentionally created just for marketing purposes.

One awesome advantage that artists have over most businesses is that your content is already great. You don't have to go hire someone to create something great to show off on your website, because that's what you do! With a few tweaks and some hustle, you can make your art spread around the Internet like wildfire.

Writing good titles

Earlier in the section about what makes a great artist website, we talked about the importance of page titles. This is also important for blog posts. Search engines look at your blog post title as the primary indicator of what the blog post is about.

What makes a good title? Something that makes people pay attention and take action—whether it's click, open, or buy.

This is usually something that gives people a clue about what the content is and how it benefits them, e.g., "One Weird Trick to Help You Lose 20 Pounds" is much better than "New Dietary Supplement."

This example headline tells me a specific benefit of the product. The idea is that people don't care about the product—they care about what it will do for them. These same copywriting ideas apply to marketing your art as well. The best way to write good headlines is to copy them from successful publications—especially magazines and sales pages. You can usually see a formula or template in how the title is written.

For example, you have "Creating Computers that Innovate." So, "Creating _____ that _____" is the formula.

Another example: "Macrame and Why It Isn't Dead." Macrame may be out of vogue right now. So what I have come up with is something unconventional and why it works. That's a really good type of headline that drags people in.

There is an old standby formula that says, "How to do _____ so that you can _____." Maybe it's "How to collect my art so you can brag to your friends" or something. That's a good headline.

Good subject line templates

Template: X number ways to do Y.
Examples:
Five steps to collecting art that will make your friends green with envy
Three pieces of art that will make your friends feel safe and
 comfortable in your home

Template: Do you do X? Maybe you should/shouldn't.

Examples:

Do you collect sketches? Maybe you should.

Do you offer artists the lowest dollar? Maybe you shouldn't.

Do you collect up-and-coming artists? Maybe you should.

Template: How to do X.

Examples:

How to brighten a room with art

How to light your art

How to preserve your art

Template: Why I did X.

Examples:

Why I changed my painting style

Why I paint pictures of third eyes

Why I don't do portraits anymore

Capturing your own examples

Much like many artists keep a collection of art that inspires them, good marketers keep a collection of marketing that inspires them. Subscribe to a few good newsletters and keep an eye on their titles. Put those titles into a spreadsheet. Look at magazines in the grocery store aisle; they almost always have really good titles. Put those into your spreadsheet.

Next time you go write a blog post or an important e-mail newsletter, refer back to this spreadsheet for title ideas.

I have a great title, now what?

Form sharing alliances.

One of the most important things I do is have a close cadre of people who are willing to share the things that I post online. It's not every post, but when I have something I consider especially good, I will reach out to them and ask them to share it on social media or with their e-mail newsletter audience. I do the same thing for them.

Here are a few things your allies should have:

- an enthusiasm for your art.
- at least a few of them should have larger followings than you.
- a strong presence on at least one social network that is relevant to artists—DeviantArt, Facebook, StumbleUpon, Pinterest, Etsy, etc.
- a strong mailing list.

Other things you can do to encourage people to share your content:

- **Ask other people if you can help them promote their work.** This works wonders. Try e-mailing them and saying something like, "Hey, I'm trying to become more active in sharing things online. I really like your work, and I was wondering if there is anything in particular you are trying to promote right now? I can share it on my social networks, e-mail list, or (come up with something else). Send me a link and I'll see what I can do!"

 Generally, most people will jump at the chance. Just remember, it's not a direct "I do this for you, you do this for me" kind of relationship. You're building up good will so that people are more likely to share your work in the near future.

- **Actively comment on others' blogs.** Being involved in your artistic community is a good way for people to start remembering your name. In addition, most blog commenting tools allow you to post links back to your own stuff. Don't be spammy, and use that link wisely.
- **Curate your favorites.** Etsy collections are all the rage. Share your favorite art with your audience on a regular basis. People you highlight will be flattered and notice you back. This is highly effective in the handcrafted-items niche—more artists should do this!

Now once you've started building your blog content and you have people coming to your site, you have an opportunity to do the most important thing for the long-term viability of your art business: build your mailing list.

BUILDING AND MAINTAINING YOUR LIST

The most valuable business asset that you can create as an artist is a list of people who have bought from you or who are interested in buying from you. Over time, accumulating a list of customers enables you to more easily generate new revenue and buzz about new work. It is much easier and cheaper to market to collectors who are already familiar with and enthusiastic about your work. In addition, having a list of interested collectors can be leverage to get you into existing high-end galleries.

How many times have you had someone tell you they love your work but can't buy it right now? What do you usually do? Tear off a piece of paper and give them your e-mail address and phone number? Give them a flyer and a business card?

I would imagine that a lot of artists have the same experience—many times each show.

If you want to remind all of those people who loved you at one time to buy your work when they have some extra cash, you need to build a mailing list. A list can be your secret weapon for creating long-term residual sales and building a fan base around your work that sells your art for you.

So—how do you build a list? I'm glad you asked.

To start, you need to start collecting names, e-mails, and physical addresses. When your work is shown at art fairs, craft fairs, galleries, and other places, put out a sign-up sheet for people to opt in to your mailing list. Write something like this on the top of the page, "Sign up to find out more about my upcoming work and studio process. You'll get an e-mail newsletter once each month." Then divide the paper up into three columns labeled Name, E-mail, and Address.

Encourage people to sign up. Don't be pushy, but as you have conversations with people who like your art, invite them to sign up for the list if they're interested in hearing more from you about your art. Do the same when someone buys something from you.

Michael Whitlark, an artist in North Carolina, does something very smart. After every show that he does, he e-mails the people he met at the show and reminds them who he was and what they looked at—then he includes in the e-mail a link to buy the piece and, in some cases, a coupon code for a small discount if they buy within a couple of weeks. This is a great way to create immediate engagement and sales.

Your list may start off very small. It might be just friends and family. Here's what you don't do: Don't just dump all of your contacts into a list and start e-mailing them your art. By law, you have to ask people

for their permission to send them marketing messages via e-mail. If you don't, you're a spammer and subject to antispam laws.

You should also collect names and addresses on your website. Develop an opt-in box and display it prominently so that people can sign up to receive e-mails from you.

I find that many creative entrepreneurs know they need to build a list of subscribers in order to successfully market their creative goods online—it's been on their "To Do" list for months, in fact—but they haven't gotten around to actually doing it yet.

Why is this?

Turns out the problem is something else they've heard about—something that sounds scary, labor-intensive, and way too time-consuming—and this something is called a "lead magnet" or an "irresistible free offer" (IFO), which is something of value you give away for free on your website in exchange for an e-mail address.

Here's the thing: If you're marketing your art or creative goods and services online, you already know there's a lot of competition.

So to really turn up the juice and get subscribers interested in signing up to your list, you need to do more than simply slap up a generic e-mail opt-in form on your site and call it done. You need to offer something of value your target audience will love, something they would be happy to exchange their e-mail address for. And because so few creative entrepreneurs are doing this, you'll gain an instant competitive advantage by creating a free offer and getting it up on your website.

If all of this seems overwhelming, just know that this is an iterative process, so don't let the perfect be the enemy of the good, as the saying goes—just get something up on your site to start, and course-correct as you go. You want it to be high quality, but your initial IFO does not need to be perfect.

Here are a few things a great opt-in offer will do for you:

- It will establish trust, goodwill, and reciprocity with your audience.
- It will demonstrate that you care about your audience and understand their needs.
- It will give your audience a no-risk way to get to know you and your business.
- If done correctly, it will generate interest and desire for your creative offerings.

HOW TO FIGURE OUT WHAT KIND OF IFO TO CREATE

Something that is a little bit valuable to people is better than nothing. Let me also emphasize that the value doesn't have to be monetary. So how the heck do you know what you should create as your lead magnet?

I think of it as a three-step process. To create a really compelling IFO that gets e-mail sign-ups, you first need to know who you're trying to attract. We talked about that in chapter 3.

Once you know who you want to attract with your IFO, you need to figure out what they struggle with or what they're looking for. Create your IFO for this target audience based on a problem they want to solve or a pleasure they want to gain. For artists, this usually means that you are speaking to one of the following problems that a collector might have:

- picking art that will grow in value
- picking art that will look beautiful on the wall

- picking art that will create a feeling of happiness/contentment/ joy/peace
- picking art that will inspire you them to take action

Add some *you* flavor into your opt-in offer. Now I know what some of you are thinking, because I hear some variation of it from my creative friends all the time: "but it's fine art/jewelry/photography/underwater basket weaving. There is no pressing problem to provide a solution to."

To reiterate: People aren't buying your art because of the item itself. They are buying what that item represents. They're buying an emotion or an experience that they want to repeat each time they experience your art.

Again, let this be easy. What you're doing with your IFO is creating something valuable and relevant to your target audience. People want things that make them feel good, look good, and be the discoverer of cool things. Fine art and other creative offerings fall into the "pleasure they want to gain" category, so don't worry that you need to solve some immediate, hairy, big pressing problem with your free giveaway.

When I'm brainstorming free opt-in offer ideas, I like to break the ideas down into categories. Again, knowing your target audience is super important for getting this right. For example, what does your ideal audience value the most? Is it exclusive/insider access, a peek behind the curtain at your artistic process, special offers and discounts, inspiration, information and advice, free training, your insights on creativity?

Another way to think about this is to figure out what people who buy your stuff need related to the thing you sell. For example, jewelry designers might give away a beautifully designed PDF with "Ten Must-Know Tips for Cleaning and Storing Your One-of-a-Kind Jewelry," or something similar.

If you're trying to build relationships with collectors, share the kind of information that generates interest and desire for your offerings. Storytelling around your art is a very effective way to do this. We humans respond to stories in a much more visceral way than we do facts and dry information, so an opt-in offer that taps into this dynamic could work well. For example, a video that shows you working in your studio and discussing your creative process, or displaying works in progress while explaining your inspiration for them, or simply telling the story of how you got started.

Think about the questions people ask most often at your shows and openings and create a beautifully designed PDF that answers these questions.

Create a resource guide for collectors. This could be a simple PDF that shares ten tips about collecting fine art. This works because you're helping your audience with something they already do—collect art—related to what you sell. Bingo! Amp up the curiosity by giving it a compelling title like "The Truth About Collecting Fine Art: What You Absolutely Must Know Before You Buy Your Next Painting."

From the exclusive/insider access category, you could offer an invitation to a private Facebook group where you share works in progress, upcoming show information, and special Facebook-only promotions. The key here is to give away access to a private, invitation-only Facebook group, not your regular Facebook business page.

Alternatively, you could tease getting on your e-mail list by offering subscriber only access to special promotions, along with information about upcoming events and artist appearances, exclusive access to studio previews, and first looks at new works.

You could offer a nicely designed gallery and event calendar, delivered digitally. Or go crazy and send a printed version if you have the lux-

ury of time and dollars. To make things really simple, if you have a blog you update regularly, you could simply offer to send your blog posts via e-mail. If you go this route, you want to be sure to package and position it to make it something special, for example, by calling it "The Insider Club Letter," "Collector's Club Updates," or similar.

If you have illustration or graphic design skills, you could give away a set of free graphics, such as a set of social media icons that are done in the style of your art.

If you're a wedding photographer, styling tips for brides to help them look their best on camera on the big day would work well. If you're a portrait/lifestyle photographer, you could do something similar—think tips and tricks for helping your clients feel comfortable on camera. For example, if you find that your clients often freeze up when being photographed, you could create a nicely designed PDF called "The Shy Person's Guide to Exuding Confidence on Camera."

Offer a checklist of what to bring to a photo shoot, based on the kind of photography you do: how many outfits to bring, what colors photograph best, posing tips, etc. Position and package it with a compelling title like "Ten Ways to Look Your Radiant Best on the Day of Your Photo Shoot," or "The Ultimate Photo Shoot Checklist for Brides," or similar. This works because it helps your client or customer with something related to what you sell, and demonstrates you care about your audience and understand their needs.

You could offer discounts and other special offers. A lot of makers use this as a free opt-in goodie, so be sure to make yours stand out by positioning it well and creating compelling copy for it. A great example of this is fashion blogger Hilary Rushford, who calls her e-mail list "The Honor Society" and teases signing up for it with the copy, "Thursday Telegrams mean first access, inside scoop & all the stylish secrets." So much better than

"sign up to receive discounts and special offers," right?

In the product category, free shipping is another favorite to offer to get people on your list, because we all like free. (And we all know how expensive shipping can be.) I recommend doing this only for artists who already have established revenue, or who are shipping paper or similarly light-weight things.

Here's one I really love—how about styling advice? Because if you've ever bought something fabulous then not had a clue about how to wear it or how to match it with what you already own, then you know how frustrating this can be. Simply create a guide to wearing your jewelry and how to integrate it into any wardrobe, and deliver this information via a nicely designed PDF.

Take the idea above up a notch and offer access to private boards on Pinterest that show how to style your jewelry with any kind of wardrobe. You could really go nuts here, showing each piece in your collection and how to wear them in every kind of setting: casual, black-tie, weekend, etc.

Once you have your free offer down, implementing a way to deliver is most easily done through your e-mail management system and download links on your website. Simply upload your gift to your website, and copy the link to where that item is on your site. In your final confirmation e-mail after people sign up for your list, include a link to that item. Supereasy!

USE AN E-MAIL MANAGEMENT SERVICE (EMS)

It's easy to e-mail from your free webmail client, but don't make this mistake. Most EMS will integrate your Web sign-up forms with your list for you, track the number of people who open your e-mails, and the number of clicks your e-mail generates. That way you know whether the things you are writing about are generating interest. I recommend MailChimp.com as a free e-mail management service for artists with a list less than two thousand. It's easy to use and creates high-quality e-mails that really stand out. Plus, the creators of MailChimp have a great sense of humor.

In addition to giving you tracking options, using an EMS keeps you from running afoul of the law. There are antispam laws in place in just about every country, and these companies specialize in making sure your e-mails are compliant. They give you HTML templates for your e-mails, they give you up-to-date guidelines on what you can and cannot include, and they handle the double opt-in process (someone signs up for your list and they get an e-mail asking them to click a link to confirm the opt-in). They also provide a one-click unsubscribe option, which you definitely want to offer so that people won't mark your e-mails as spam.

How often should you contact the people on your list? It has nothing to do with a certain number of times per week or being afraid of spamming your people. It has everything to do with how much value you add to someone's life. How good of a communicator are you?

I really hate the term *newsletter*. When I hear artists talk about an e-mail newsletter, all I can think of is the really boring updates that artists send out that have no personality and no flavor. The biggest mistake that I see artists make with their mailing list is being boring. They send out a reminder once every couple of months, and that reminder usually has

nothing besides a formal invitation to some gallery opening or to view a new piece of work that the artist has created.

If you are going to be a truly successful artist, your mailing list is your opportunity to build your platform. All of the stuff we talked about at the beginning of this chapter—writing about your art, about your passionate subjects, and giving people an insider look into your work—goes into your e-mails.

Some artists write weekly. Some write a couple of times per month. I would recommend never going more than a month without contacting your list, and you should set it so that it comes out at the same time every time. My newsletter goes out every Tuesday at 7 a.m. Eastern Time. As a rule of thumb, if people are reading your newsletter, responding well to it, and you are having fun, then you are probably at the right frequency.

Artists often ask me what the difference is between blogging and e-mail newsletters. Think of your blog as your opportunity to write out your long-form thoughts on whatever subject matters most to you. Your EMS is the tool you use to let everyone know that you've written a new blog post or have some other important announcement.

In the age where social media is what everyone is talking about, it turns out that e-mail is still the far more powerful platform people to buy things. On average, people view a particular e-mail more often than a particular social share, and click links in e-mails significantly more often than they do on social media sites.

This can be for a variety of reasons. Consider the scenario where a person has signed up to a particular e-mail list because they are interested in the topic, enjoy reading the sender's writing (or viewing the sender's art), and want to hear more from that person. This is very different than following that person on a social network, to receive short chunks of text or a single image at a time.

Most important of all, e-mail is one of those rare communication platforms that you control. You invite people to sign up to your list, and once they've signed up to hear from you, their contact information is yours until they ask to be unsubscribed. If your e-mail management system shuts down, you can upload your list to a new EMS and continue onward.

AUTORESPONDERS

Whatever EMS you use, you should make sure that you can generate a series of autoresponders. Autoresponse e-mails go out whenever someone signs up for your list. It makes further offers, reminds people what you have for sale, or relays any other message you might want them to have.

Done right, this looks like a personalized series of e-mails sent to new potential collectors. It walks them through your work as an artist, helping them understand how you are relevant to the world and why they should collect your art.

For many artists, an autoresponder sequence might include walking someone through the history of your work as an artist, your latest series, or some other interesting bit of information. Each e-mail will give that collector a tiny bit of information about you and help you build a relationship with them—all while you are working on other projects!

SEGMENTING YOUR LIST

A few years ago I sat down with an artist from Hawaii who wanted to leverage her twenty years of off-line sales into online sales so that she

could move to another country. She had the contact info for several hundred people who had purchased her work over the years. We broke the list down into three distinct categories. Once we broke everyone into these three groups, my client sent each group an e-mail introducing them to her new website and letting them know that she had an e-mail newsletter coming soon.

Collectors. People who purchased multiple pieces of art from my client. They knew her name, and she knew them. Many of them had purchased large originals at a premium price. She sent individual e-mails to each of them, with a personal anecdote from their previous interactions. Then she added a standard introduction copy about her new website and let them choose whether they wanted to add themselves to her new e-mail list.

Buyers. People who had purchased one piece of art, but not more. Most of them would not have remembered my client. She sent a single mass e-mail, but still inserted their name, thanking them for purchasing her art, and inserted her standard introduction copy.

Fans. People who liked her work a lot, but who had never purchased anything from her. They signed up for her mailing list at some point, but had never actually gone through with a purchase. She sent a single mass e-mail with the standard introduction copy.

The result of all of this effort was a huge boost in sales. She sold two originals that had been sitting in inventory, was hired for two new commissions, and sold a handful of prints as well.

The lesson here is that you need to nurture different segments of your audience in different ways. Those high-value collectors get personalized notes. Everyone else gets put into a nurturing program like your autoresponder series.

INCREASING OPEN RATES AND CLICK RATES

Most artist e-mail lists have an average open rate of around 30 to 40 percent. If your list is very small, it might be higher. If your list is quite large, it will likely be lower. If you have the occasional open rate lower than this, pay attention to the following things you can do to increase your open rates.

Pay attention to your subject lines. Earlier in this chapter, when we discussed subject lines, were you paying attention? Good, because that's the number one factor in determining whether or not someone opens your e-mail. "Jane Doe Artist's Newsletter no. 8" is the *worst* subject line—but I see it all of the time.

Write interesting content. If you have great subject lines but terrible, boring content, then people will eventually stop opening your e-mails. Luckily for most artists, this is not the problem. If you lean on your images and create simple descriptions, you'll probably get by just fine until you become a better writer.

Use A/B testing. Most EMS have the ability to let you write two subject lines, split your list into two smaller groups, send one subject line to each group, and show you which

Increase email open rates

DO A/B split testing

Interesting subject lines

Interesting content

give good email

send at optimal times

subject line gets the most opens. After doing this for a while, you'll start to see what kinds of subject lines are best for your audience.

Test send times. Finally, you should consider which time of day, and which day of the week, is best for opens. Tuesday and Thursday mornings tend to work pretty well because people check their e-mail first thing in the morning. On Mondays people are focused on getting work done, and on Fridays people are distracted and ready to enjoy their weekends.

TAKE ACTION

Hopefully from this chapter you get the idea that building a list of buyers and interested fans is the most important thing you can do for your art business. We've given you a lot of ideas on how to do that, and obviously there are many more things you could be doing. We didn't even get into snail mail—but that's okay.

One of the biggest excuses for failure to take action is when people say, "I don't have enough information." There are a million little things that you'll learn so much faster if you just go and do the thing that you're afraid to do. Break your tasks down into small chunks, and go make it happen. If you're not sure where to start, start anywhere, and what you need to do will become readily apparent.

SOCIAL MEDIA AND PR

HOW ARTISTS CAN BE MORE SOCIAL WITHOUT IT SUCKING AWAY THEIR SOULS

Nowhere is the metaphor of the online art salon more appropriate than in social media. Social media is like an always-on cocktail party. You can find different groups of people to interact with, except you can leave and come back whenever you want.

Yes, I'm going to beat this metaphor to death. And yes, you'll need to learn to be more social if you want to be a financially successful artist. Even if you're going to hire someone to do it all for you, you still need to learn to interact with others effectively, in real life and on social media.

Before we jump into the specifics of how to make social media an effective marketing tool, let's go over a few things.

If there's one sector that typifies the ever-shifting, ever-changing nature of technology, it's social media. When I was in college, MySpace was absolutely huge—for about two years. Then Facebook came along. But there are

Good fortune through action

social media success
for artists

You set up a great profile.

You connect with tastemakers.

You track your progress

You become skilled with photography and editing tools.

You build your following with hashtags

You make and show art in a series.

Fan-generated fun fuels your success.

a plethora of also-rans. Friendster. FriendFeed. Ping. Orkut. Diaspora. There's dozens more. Never heard of them? That's because they failed to gain traction and ended up being sold or shut down.

Because of the constant state of flux in online social networks, they are probably the easiest way for a new artist to get any attention at all. New communities form online and if you're one of the early participants, you can get a lot of free attention. If you are a little later to the game, you can still get a lot out of it. The individual strategies for each social network will constantly evolve. Because of that, in this chapter we will attempt to cover the principles of a good social strategy without getting deep into particular tactics, because those tactics will change as social media platforms evolve. If you want the latest updates on how to use the latest social tools, I would recommend subscribing to my blog at theabundantartist.com/blog.

In chapter 6 we introduced the concept of digital sharecropping. That's when you are creating content on someone else's platform in exchange for publicity or exposure. The platform gets to show you ads in whatever context they see fit. They use your presence, your art, and your other content as a context from which to show the ads. The platform gets

rich and you get an audience. It's a win-win until the platform gets so big that they have to start changing the rules. At that point, free exposure for your art starts to go away. As you're reading this, you might be thinking Facebook, but the same thing happened on MySpace, and will continue to happen on any free platform.

Social media is social. While this chapter is all about selling your work via social media, keep in mind that the foundation of social media is the social part. It's not a transactional platform. People are on Facebook to communicate with their friends and share cute cat videos. You have to put something into it to get something out of it. Since so many artists tell me that they struggle with being social—they'd rather be in the studio—I feel it's important to remind you that social media requires a social element to be successful.

HOW NATASHA WESCOAT BUILT HER BUSINESS ON FACEBOOK

The following is a blog post that Natasha Wescoat wrote for theabundant artist.com about how she sells her art with social media. It has been updated with some current numbers for 2015:

For the last ten-plus years, I've offered my work online through various venues, with the support of my own website and organic marketing (social media, word of mouth, etc.). But it was in 2010 that I recognized a potentially sustainable source of income in one particular social network.

I have made over $50,000 selling my art on Facebook, and I will show you how you can too.

Facebook, despite its constant scrutiny, is a growing giant and it's not going anywhere anytime soon. According to allfacebook.com:

Facebook currently has 1 billion+ active users.

Facebook accounts for 1 out of every 5 page views on the Internet worldwide.

Facebook users share over 100 billion connections collectively.

Over 50 percent of the population in North America uses Facebook.

Since Facebook went public, along with it's growing integration into every website and social network in the world, it's becoming a force we cannot ignore. Everyone's mom, grandfather, cousin, dog is on Facebook. It's becoming a rich resource for finding current and new audiences. Everyone is on getting on board.

HOW I BEGAN

A year after I created my own page, I began to actively post and correspond with fans. People loved to share pictures of their favorite art or ask me questions about my work. I wasn't really into it too much, and didn't see the potential of the site so I rarely logged on or answered questions. I had no idea how effective or useful it would be. Within a year, I had stopped selling work on sites like eBay or Etsy and took time off to work on other endeavors. When I wanted to sell an artwork or offer prints, I'd just post them on there to see if anyone was interested.

To my surprise, they *were*.

By 2010 (a year in), my fan base grew from three hundred to a thou-

sand as old followers and new found me on Facebook. I began to share the link to my page on Twitter (where I had 9,000+ followers) and on my blog, which I'd been writing since 2006. I realized the potential and began to experiment on what worked and didn't work for me and my personal following. By 2011, I was selling art on Facebook exclusively, making over $50,000 in sales from my original paintings and fine art prints.

So, *how* exactly did I make this work in two to three years? Here are some practices/methods I've used that helped not only build my fan base, but increase engagement, develop interest, and increase sales.

EIGHT KEYS TO CREATING YOUR FAN BASE AND SELLING ART ON FACEBOOK

The first thing to understand is, it's most important to develop a reputation with your collectors/fan base before you can really start selling your art. It's important to engage with your collectors and build relationships. This is particularly wonderful for us as artists, because you really don't have this opportunity in a gallery setting unless you have the time to be out and about all the time!

ENGAGE

1. **Start conversations/use engaging tools.**
 Post a photo of work you are developing (progress pictures).
 Post an artwork from your past, childhood, present. Show where you've come from, what you're working on (series), or an artwork you want to offer.

Ask a question. Create posts that ask them questions about their interests and personal lives, ask about their work, ask about current topics. Use topics that relate to their work or your personal audience. Everyone is different.

Start a topic. Talk about your process, what you're working on, what you did today, etc.

People respond most to things that are visual or involve *them*. People love to talk about themselves, and they'll be interested in sharing their own stories, thoughts, interests! Get them going!

2. **Make it fun.**

Create contests (photo contests, commenting contests, liking contests). You want to create things that inspire them to share or participate. Offer an incentive: winner gets your print of the month (or choice), someone gets a discount in your shop, one of ten commenters will get a free print, etc.

Encourage fans to share pictures of their collections, favorite artwork, or their dog—whatever it is that could be related to your artwork, your brand, or your web presence.

3. **Don't ignore the stats.**

Research your audience. Use Facebook Insights to understand the type of people that are "liking" and engaging on your page, and from there you can learn and develop your audience.

Study how to use Insights so you can better read the data that is offered to you. Find other tools that might help you engage with your audience.

BE CONSISTENT

4. Create a schedule/system.

Decide what time of day, how many times a day, how many times per week you will post, and what type of content you will post.

Create a day/time for what content is shared: New art on Fridays? Studio Sales on Sundays? Illustration of the day Tuesdays? Fan Chat Thursdays?

5. Sell your art with a plan.

Create sales goals and develop a system that will help you reach those goals.

Determine what you are willing to sell your artwork for. Will you offer prints? Will you offer just small artwork or everything you create? I never allow an original artwork to sell for less than $200, but this is all dependent on your fan base, how many follow you on Facebook, what you offer, how long you've been an artist, and who your audience is.

Do you want to offer your art directly on Facebook or promote your other sites where the art is available?

CREATE URGENCY

6. It's important to create an urgency and rarity for your work on a social network because everything is posted in real time, exposure on Facebook is short-term, and not every follower will see your posts.

With original art, I'd give them a chance to name their price, auction style. I say, Make an offer and it's yours!, which creates an open opportunity for them to name what they'd pay. Allow yourself as much time as you want to see how

many offers you get. The longer, the better, but if you feel it necessary to keep short, do so. I only offer originals for up to twenty-four hours for bids. After that, if there is nothing, I delete and move on. I might offer the original later on a different day and time because some days are either bad timing or most people aren't really on their Facebook.

Use sayings like "The first (number) of people to comment" or "The first one to say 'SOLD!' can purchase" to create the urgency to reply. I've found that if I simply post payment information for artworks or link to an artwork, there is less of a chance at making a sale.

Create rarity with limited times or limited offers. Certain prints or specials will be available from this day to that day, or for twenty-four hours, or until the Friday of that week. Something of that nature, where the special will not be available anywhere else and is not done on a *regular* basis. It's completely genuine and legitimate as a form of selling art. Disney does this with their classics and it has worked well for them.

Creating urgency not only helps keep your fans' attention but helps increase engagement, which in turn will help increase the exposure of that particular post across other timelines. More likes, comments, or shares equals more exposure for that post.

INVEST IN PROMOTION

7. Advertise your page.

I've found that with even the smallest investment in advertising, you can increase your fan base as well as

potential sales through the use of Facebook ads. Really study your Facebook Insights and determine the best plan for advertising. Sometimes I only advertise with my spending limit at $30 to $50 at a time. Facebook offers a wonderful system that makes it simple even for the novice. Play around with the advertising system a few times and you will get the hang of it. From there, decide how much you're willing to spend each month, every few months, or year. Perhaps you only advertise for a week or a few weeks around a special event or artwork you are working on.

8. **Promoting posts really works!**

You are able to promote a particular post (perhaps you are offering a limited print or original artwork for sale) for anywhere from $5 to $30 to reach a certain amount of your audience. That particular promotion may last anywhere up to three days. Promoting pages increases the chances that post will be seen by your fans for a longer period of time. This is great because, in reality, not everyone will see that post. People log on at different times, for different lengths. Not everyone goes directly to the page to read what's happening. I have fans who follow me regularly but might miss one post or they happened to be on vacation that week or don't see that artwork I offered three times that month.

And if at any time you wish to cancel or pause a promotion, you *can*. Sometimes I'll reach a certain amount of sales that I wanted and pause the promotion. You might only spend 30 cents or $1.40 when you promote a post.

So, how do I do it?

- I post regularly—almost every day.
- I offer art weekly, through studio sales, special limited-edition offers, and print sales.
- I promote my Etsy shop, eBay, auctions and other sites through Facebook.
- I revisit old events, old artworks, and past experiences for content.
- I syndicate my blog and social networks to the page to increase content, social engagement, and product awareness.

The strategy Natasha outlines here is a great example of guiding principles that work on other social networks and for all kinds of marketing, not just Facebook. Engage. Be consistent. Create urgency. When it works, put more money into it until it stops being profitable.

It's worth noting that your Facebook posts are seen by a progressively smaller group of people as Facebook gets bigger and optimizes the user experience for more money or for a better experience for their users. As of this writing, the average reach for a Facebook post by a business is about 5 to 10 percent of the people who like the page, unless you pay for advertising.

The reason for this decline in reach is somewhat controversial. Some people claim Facebook has swindled its users. Facebook says it de-emphasizes promotional posts to create a better user experience so that people don't give up on the platform.

Just focus on this: Does Facebook work for selling art? The simple answer is yes. The bulk of Natasha's income still comes from Facebook. In my own tests with a variety of artists, I have seen some outstanding sales results. I recently did a test with Dalani Tanahy, an artist from Hawaii. We spent $30 on Facebook advertising and she saw over $5,000 in new commissions and students.

It's not possible to entirely explain Facebook's complex advertising

platform in this chapter. We would need an entire book, and that book would probably be out of date by the time it went to print. But I'll endeavor to explain what we did with Dalani's ads. You can access these tools at facebook.com/advertising.

Highly specific targeting. Facebook's ad platform allows you to be highly specific with who sees your ads. For Dalani, who makes kapa, a traditional Hawaiian art, we looked at her Facebook Insights, the analytics tool provided by Facebook, to see the stats on the people who like her page. Based on that data, we created a targeted audience for her and divided it into two groups: women over eighteen who live in Hawaii and speak English; and men who live in Egypt, speak Arabic or English, and have an expressed interest in arts and music.

Great images. Dalani had her work professionally photographed, so she had lots of good images of her work available. We grabbed a couple of those images and put her face on the picture with Photoshop. It's important to show your art in your ads—specifically the art that people will see when they click on the ad.

Testing. Facebook's ad platform allows you to test several images. You upload several images and Facebook will automatically vary the ads it displays for you and you'll be able to see which ones get the most clicks. We tested three different images over twenty-four hours to see which ad got the most clicks; we settled on one to run with for the next three days.

We then tried variations on the titles for each ad. It was something like this: "Buy Kapa Art" and "Do you like Kapa?" and "Dalani Tanahy, Kapa Artist." We picked the title that got the most clicks and kept going.

We could have kept going and tested the ad copy, mobile vs. desktop, and other factors. The point is not to guess, but to put up a few options and test to see which ones work best.

Landing pages. The final key to succeeding with paid ads is to look at

your landing page (the page that people go to when they click on the ad). Does it match the content of the ad? Is the art in the ad showing on the landing page? Is the title the same or very similar? Is there a big button to tell people exactly what they should do next: buy, sign up, join a newsletter, etc.?

Facebook's ad platform is constantly evolving. We maintain an up-to-date training course on the Facebook ad platform for artists at courses .theabundantartist.com.

APPLYING THE FACEBOOK STRATEGY TO OTHER SITES

Reaching back to the salon metaphor, it's important to remember that what we call social media now is just another iteration of what human beings do all the time: congregate and make connections. Just like at a salon, people respond when you ask them interesting questions. They respond when you ask them about their interests and likes. People develop affinities for those they like to interact with online, and you need to be there when they expect you to be there.

Engage. Be consistent. Create urgency. When it works, put more time and money into it until it stops being profitable.

Each of those principles works

slightly different for each social media platform. So how do you know which platforms are great and which are a waste of your time? I'll share some of my thoughts for now, but as I said, keep in mind that all of these platforms are constantly changing.

Instagram.com

Facebook and Instagram are the two most useful social media sites for artists as of this writing. We've covered Facebook, so let's talk about Instagram, the smartphone-centric social network owned by Facebook. I've interviewed artists who are doing exceptionally well on Instagram, and tested tactics from various other sources. I'm seeing that Instagram is a green-field opportunity similar to what Facebook was in its early days. The filtering algorithm is pretty lenient, with average engagement being as high as 30 percent of followers.

The following is a summary of what I've seen work on Instagram.

Make some great art and be consistent. This should be self-evident, but it needs to be said: you should be continually striving to improve the art you make. You also need to be consistent and make art in a series.

Set up a great profile and learn to photograph and use the editing tools. These first two points are the absolute minimum barrier to entry. If you can't do these, you won't get noticed. Far too many artists have Instagram profiles with no pictures, no description in the profile, and poorly composed, poorly lit pictures of their art. You can take serviceable photos with even cheap smartphones, and late-model iPhones are as good as many point-and-shoot cameras. The Instagram editing tools are pretty useful, especially for a smartphone app. You can edit colors and exposure and have limited cropping. The filters alone are usually enough to correct any issues you might have with low light or similar problems. Take good pic-

tures, then use the editing tools to adjust your images to make your art look like it does in real life.

Embrace the Instagram hashtag culture and build your following. Familiarize yourself with hashtags. If you've been on Twitter for any amount of time, this should be familiar to you. You'll often see people add words like #art or #artistsofinstagram in the description of the images that they upload. These hashtags become clickable links, and you can also search them with the Instagram search tool. This is how people discover new artists. You can find popular hashtags by searching Instagram and looking at the hashtags in popular posts, or you can use a tool like Iconosquare to see the most popular hashtags in various categories.

The ideal number of hashtags is flexible, but it's probably somewhere in the three to eight range. There are broad hashtags like #art, #acrylics, #oils, etc. You can also put hashtags around nearly anything, but I would consider adding tags around your medium, subject matter, and the location your image was created. This last one helps people find local artists.

Instagram has a culture of being open to awesome stuff. While Instagram is currently testing a limited number of ads, people aren't used to being sold to on Instagram, so keep your pitching to a minimum and instead be a lot more fun. You'll accumulate followers quickly and when you do mention you have something for sale, people will be more responsive.

Identify the tastemakers. Just like in every social group, there are a handful of people on Instagram who are very influential. You can find them by searching for popular hashtags, doing Google searches for "best _____ on Instagram," or by researching influential people in your art niche and checking to see if they have an Instagram account.

They might be art dealers or curators with big followings. They might

be celebrities who are really into the kind of art you make. They might be bloggers or YouTube stars with huge followings. Whoever they are, be sure to follow them and interact with them on a regular basis. Comment on their work and share it with your friends by tagging them in the comments.

Track your progress. It's easy to get lost in the never-ending stream of new stuff. If you're intentionally going about building up a new audience, then it makes sense to write down how many followers you have on a given day and set a goal of adding 10 percent more followers in a week. Track what you do that gets more followers, then do the stuff that's successful and skip the stuff that's not.

Try some fan-generated fun. Instagram can be really great for contests, giveaways, and fan-generated fun. Brady Black, who goes by @seriouscreatures, has an awesome ongoing series where he encourages fans to post pics to Instagram and tag them with #scdrawthis. Every couple of weeks, Brady will pick a fan image and draw over it with his iPad and repost it as a new image, attributing the original to the fan that posted it.

There are a lot of options out there. Truthfully, I think most emerging artists can ignore them and focus on Instagram. That's where collectors are hanging out. That said, there is some value in other sites and I've outlined some thoughts below.

Tumblr.com

Of all of the "other" sites out there, Tumblr can have the most potential for artists. Tumblr is primarily visual and has deep ties to the fashion world, being the blogging platform of choice for Fashion Week. There are some major art galleries with Tumblr accounts, and a handful of the most fa-

mous artists in the world, like Austin Kleon, use Tumblr. Tumblr's audience does skew young, so that's one challenge, but the biggest challenge for most artists trying to sell using Tumblr is that most of the art-related conversations happening there are between art professionals—artists, gallerists, curators, etc. Most art buyers don't participate in these conversations, so it's up to you on whether or not you want to be a part of that conversation.

Pinterest.com

Another visual-first social network, Pinterest focuses on creating collections of images called "pins." Users can then click on the pin to be taken to the original page that the image appeared on. Pinterest has proven that even though they are much smaller than Facebook, they can drive a massive amount of traffic for retail sellers. If you are an artist selling art, that includes you. The downside is that Pinterest's audience appears to be mostly interested in artisan crafts and inexpensive paintings. This is in stark contrast to Instagram and Tumblr, so I maintain that both of those sites are a stronger secondary alternative to Facebook.

LinkedIn.com

LinkedIn has been effective for a handful of artists I know who really focus on art licensing and corporate purchases. If you are an artist that is focused on these areas, there are several groups in LinkedIn that would be a good place for you to connect with similarly minded artists, agents, and other professionals. Those groups include: Visual Artists and Their Advocates, The Art of Licensing, and Freelance Artists and Designers. To find these groups, go to LinkedIn.com and search those names.

Twitter

The Twitter culture tends toward short, quick text conversations. While Twitter recently introduced updates that have made it more visually oriented, most artists I know have become entrenched in other networks like Facebook and Instagram.

Google Plus, Ello, Diaspora, DeviantArt, and others

There are *a lot* of other social networks out there. Most of them are relatively small—less than a few million users and not a lot of activity. It's tempting to go out and post to as many of them as you can, but my recommendation is to avoid them and stay focused on building a following on one or two networks.

One exception is when your art fits really well in a specific niche. For example, if you make Pop art, DeviantArt or Ello.co (not .com) might be a good fit for you. The niche possibilities are endless.

GUEST POSTING AND ONLINE MAGAZINE COVERAGE

Social media is popular among artists because there's no barrier to entry. You can spend hours commenting, responding, and interacting with others and *feel* like you're working away—without actually accomplishing all that much. I've worked with lots of artists who have spent hours per day for months and not sold anything.

In order for social media to be effective, you need to build your following to a critical mass. You can do it one at a time by interacting with the few followers you might have—or you can try leveraging a wider au-

dience. By participating in the wider conversation on your blog, you give yourself a voice. By guest posting (i.e., writing guest articles) on other people's blogs and magazines you give yourself an opportunity to speak in front of a larger audience.

The following are some places where you can do this.

Art blogs

There are dozens of popular art blogs on the Web. Hyper-allergic.com, which primar-

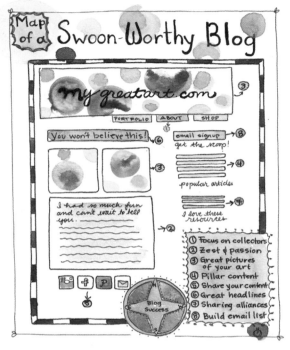

ily focuses on events at museums, major galleries, and other upper-echelon art world happenings, has nearly 1.8 million visitors per month, according to Compete.com. Other popular art blogs include Bombsite.com, Artfcity .com, ArtNews.com, boooooooom.com, ThisIsColossal.com, and dozens of others with smaller followings. Each of these sites has their own guidelines and submission policies for getting your art featured on their sites. You can visit their contact pages to find those guidelines. For a complete list of sites, along with links to their various submission pages and posting guidelines, you can visit http://courses.theabundantartist.com and sign up for the (totally free) Members Only Resource Library.

Niche blogs

Think about whatever kind of niche your art might belong in. Perhaps you paint ski racing in exotic locations like Chamonix, France; create rolling ball sculptures that pay homage to Alexander Calder; mold encaustic art that depicts the city of Portland (all previous coaching clients of mine). Each of these subjects has enthusiastic communities on the Internet. A smart artist would reach out to the blogs that depict these ideas and ask them to feature their art.

You can do a simple search for "(your niche) + blog" to find these kinds of blogs. For example, if I type "Portland, Oregon blog" into Google, I get the following results: PortlandsPretty.com, PortlandMonthlyMag .com, pdx.eater.com, and portland.wiki/local_blogs. All great results that lead to a plethora of niche blogs about various aspects of the city of Portland. Within those blogs, there are at least a handful of sites that would be excited to potentially showcase some local artists.

Most of the quality blog sites will have guest posting guidelines. Read them carefully and submit accordingly. If they don't have guidelines, don't be afraid to reach out and ask.

SETTING A WORKABLE PACE FOR ONLINE PROMOTION

Between posting stuff to social accounts, reaching out to blogs and journalists, and other promotional work, it can start to feel like a full-time job. Also, it can start to feel a little bit unwieldy. Many artists who are new to online promotion ask me what they should be sharing when, and how they can grow their own social followings. I'll share with you my own work flow for publicity.

I like to curate content for my audience. Those who follow The Abundant Artist's Facebook page consistently tell me how excited they are about the excellent content that I share there. You can do the same for your audience, tailored to their interests. This is a solid way to maintain a social media presence.

I keep a spreadsheet with links to my most popular blog posts and some sample social media posts. Twice a week I copy and paste three to five of those links into my BufferApp.com account. Buffer is an awesome tool that lets you set up a schedule for when things are posted to your social media accounts. On Monday and Wednesday afternoons, I add some things to my Buffer queue and Buffer will post them to my Facebook, Twitter, LinkedIn, and Google Plus accounts at a predetermined time, four times a day.

Since I don't want to be the guy that is always promoting my own work, I also keep a list of interesting stuff that I've read recently on the Web. I do that with the app found at GetPocket.com. Pocket acts as a simplified reader. When a friend sends me an interesting article, or I see something on social media that I want to read, I add the link to the Pocket app, using a browser plug-in. While I'm standing in line at the grocery store or waiting for the train, I can open my smartphone and read a stripped-down version of the article that doesn't have advertisements or crazy formatting. Then, if I like it, I can automatically add that article to my Buffer queue.

Then, on Mondays and Wednesdays, after I've picked my three to five articles to share, I go through the other news and interesting articles that I've read, using Feedly to curate news sites and blogs I read. I share interesting projects from artists around the world, some of the best news from the various art sites, and other fun or silly things that I get a kick out of—and it's super helpful and engaging to my audience. About once every month something that I share goes viral and gets hundreds, or

thousands, of shares, all with The Abundant Artist's name attached to it. All told, I spend around two hours per week in active social media promotion, and get solid traffic and business from that effort.

On top of that, I spend an additional two to three hours per week doing guest post pitches, writing guest posts, or doing guest interview spots on various podcasts.

This chapter has given you a tremendous amount of specific, actionable steps to take in your online marketing. Once you've set up your website and the other things outlined in previous chapters, I can't emphasize enough the importance of continuing to promote your work consistently.

I encourage early career artists I work with to set a schedule for themselves to do art magazine and blog post submissions every week, and to check their social media for fifteen minutes in the morning and in the afternoon.

To wrap up this chapter, the following is a list of templates you can use for social media posts and inquiries about guest posting.

SAMPLE SOCIAL MEDIA POSTS

Work in Progress [Title of work]: [insert image]

What should I name this piece? [insert image]

Share your favorite pet/child/work picture!—*I love to see where people work—and people love to talk about themselves. Inviting them to share their space with you or to show off their loved ones creates a bond.*

Congrats on the exhibit/show @XXX location—*giving shout-outs to fellow artists is good form and makes you a likable curator of good stuff for your audience.*

Learn about [subject of blog post] here [LINK]—*this is much better than:* new blog post [LINK]

What do you think of [NAME]'s new series at [LINK]?—*Asking open-ended questions gives you the chance to interact and talk with your audience, building trust and rapport.*

SAMPLE GUEST POST INQUIRIES AND PRESS RELEASE TIPS

Most bloggers won't like official press releases as the body of the e-mail. They want to feel like they are receiving a personalized e-mail about something that is relevant to them and their readers.

Again, follow blogger guest post submission guidelines. In the absence of existing guidelines, a good inquiry e-mail to a blogger looks like this:

Hi [NAME],

Thanks for writing about [INSERT LINK TO A PIECE YOU LIKE]. I think it's great because [INSERT SPECIFIC REASON YOU LIKE IT].

I think your readers will be interested in this upcoming show that I'm participating in. I'm working with a handful of local artists do put the show on. Dates below, and formal press release attached. Please let me know if you have questions, and I'm available for interview.

TITLE OF SHOW

Address

Date

Special instructions and price of tickets

Important tips on press releases
(thanks to the inimitable PR pro Cheryl Heppard for these tips):

- Place links in your press release to direct readers to your website, possibly your event page (use keywords as hyperlinks as well).
- Include offers that encourage the reader to respond, such as an invitation to an event and RSVP info.
- Send press releases on a regular basis, not only when something really big is happening. Announce events, workshops, partnerships, new corporate clients, etc. This way, reporters will remember you, and if a story comes up that they need a source for related to your practice, they will call you. Once a month is a good goal.
- Post your release to the Internet using AmericanTowns.com, Free-Press-Release, etc.
- Cite studies, polls, or statistics, if you can, to show how interested people are in urban development, gentrification, innovation, etc. Since art and creative work are deeply integrated with urban renewal and growth.
- Try to include how much time you spend with collectors and how you consult with them to find the perfect piece of art.
- One page in length ideally, two at maximum (400 to 500 total words).
- Double-spaced.

How to write a successful press release

1. The first line of your press releases should include: "FOR IMMEDIATE RELEASE" (or "FOR RELEASE 1/1/2016") and "For more information, contact" followed by your contact information.

2. Those same headline templates outlined in chapter 7 work here. Keep it short, active, and descriptive. "Local Portland Artist Opens Huge Show in New York City" or "Deaf Adelaide Artist's Work Collected Worldwide."

3. Hook the reader with the first paragraph. A first paragraph should summarize the five W's: who, what, where, when, and why. If you don't hook them in the first paragraph, people will give up.

4. Put the most important information at the beginning. This is a tried and true rule of good writing. Be succinct.

5. Write a release that answers questions about your business, rather than trying to make yourself look great.

6. Avoid superlatives like *unique* or *the best*. Instead, show how people will benefit, i.e., they get to feel good about working with local small businesses and supporting the arts, the art will make their life more peaceful or inspired, etc.

7. A quote from a nonbiased source like a university professor or a critic is very helpful.

8. Provide all possible contact information including mailing address, telephone, e-mail, and website.

9. Proofread and proofread! Do remember to proofread your press release for typographical errors before you send them out.

10. End your press release with "###" (without the quotation marks) after your last line of text. This symbol lets the editors know they have successfully received the entire release.

THINK LIKE A MARKETER

LET NUMBERS INFORM YOUR DECISIONS

Half the money I spend on advertising is wasted;
the trouble is I don't know which half.
—John Wanamaker

Picasso is famous for being one of the early pioneers of Cubism, one who broke the rules of painting. But even he had to learn technique. He had to learn figure drawing, composition, and color. He was tutored from a young age by his art professor father and could reproduce works by Old Masters by his early teens. Once he learned the rules of painting, he was able to break the rules in ways that were intentional and profound. His masterpieces are conversations with the world about how we perceive reality and what it means to make art.

The same principles of learning, experimenting, and evaluating apply to marketing.

Perhaps the most important rule for marketing is, Don't be boring. On some level, many artists get that, so they try to do their own marketing. But when their marketing falls flat, they aren't sure why. That's when you get reactions like, "People just don't appreciate art." The problem isn't that people are philistines, the problem is that there is a lot of competition for people's attention, so you need to figure out what works.

Learning the principles in this book will give you a foundation from which you can use your inherent creativity to market yourself in new and interesting ways. In this chapter we're going to talk about how to bring it all together to turn you into a competent marketer.

BUILDING MARKETING HABITS

Some artists do a great job marketing themselves, but so many artists come to me and tell me that they've been trying to sell their art for years without getting any results. After digging in to what they've been doing with their time, I usually find one of the following problems that fundamentally undermines what they're trying to do as an artist.

Ignoring the 50/50 rule

In a podcast interview I did with Canadian painter Matt LeBlanc, we talked about the 50/50 rule: 50 percent of your art business time should be spent on marketing and growing the business, and the other 50 percent on making your art.

"How will I ever have time to make art if I'm out marketing myself?" is the constant refrain I hear from artists. Whether you are a painter, a

software developer, a baker, or an inventor, all budding entrepreneurs go through the same problem. They think that if they just make their thing then people will just show up to buy it.

I spoke to two separate artists that were really struggling to get their art businesses off the ground. One artist was struggling because he has a very demanding day job and can't seem to find the time to work on his art business. The other artist is struggling because even though she has a large amount of latitude in how she can spend her time, she can seem only to spend time painting, not working on the business.

Both of these artists were struggling to spend more than four to eight hours per week on the business side of their art careers.

When I was building The Abundant Artist as a business, I had a day job. When I knew I wanted to leave that day job, I cut my day job hours down to forty hours per week (from the previous sixty I had been working), and set a schedule for myself. I got up at 6 a.m. every day and did some writing for about ninety minutes before getting ready for work.

Every Tuesday night, I would work from 6 p.m. to midnight, and on Saturdays I would work from 7:30 a.m. to 10:30 a.m. That's 13.5 hours per week, and it still took me two years to grow the business to the point where it replaced my income. Toward the end of my time at my day job, my hours were more like forty at the day job, and thirty on The Abundant Artist.

It was hard, and it was painful, but it worked, and now I have the freedom to do what I want with my life.

Dedicating some time for your art business is essential. Obviously it's not always going to be a full 50/50. Sometimes you have to get some paintings done for a show, and sometimes you've got a ton of inventory and you need to make some sales, but in general, the balance should be 50/50.

When your business gets to the point that you can hire someone

to handle the business stuff, you'll be able to spend more time making art. Sacrificing some artistic fulfillment now so you can go professional reaps long-term rewards in the future.

Focusing on the right things

It's possible to spend all of your time marketing, and get no results at all. That usually means you're doing the wrong things.

If you feel like you're spinning your wheels a lot, tell me if this sounds like you: On a typical day, you wake up and check Facebook and then e-mail. You make your art for four hours. Then you post some pictures to social media and spend the next hour commenting on other artists' stuff, hoping that they'll comment back and maybe share some of your posts. Except that part didn't take an hour, it took two hours. Whoops.

You write a blog post and post it to your blog, then share it on social media. Nothing happens, but you keep doing it because you've been told that it's important. Then you head over to your artists' co-op and sit at the desk and read while people walk in and out of the gallery. You talk to a few people who ask you questions, but you don't really know what to say to them. Nobody buys anything and you go home feeli.

The problem with this day is that it's full of aimless wandering. You're working, but working without a goal in mind and a specific set of objectives. Work is more productive and makes a bigger impact when you're trying to reach a specific goal.

The artists I know who make the most of their work time set some goals and deadlines for themselves. Once you have your goals, you can begin building your schedule backward from there.

One coaching client, Kim, came to me with the challenge that she loved painting on large canvases, but couldn't get enough pieces done to

do an exhibition at any of the local galleries. She had some moderate success on social media, but otherwise wasn't getting anywhere.

We set a painting schedule of Monday through Friday, 8 a.m. to noon. She had never had a regular painting schedule. After a week, we looked at what she had accomplished as a baseline. She had completed about half of a large painting on canvas. I asked her if she pushed herself, how much further could she get in the next week? She not only finished it, but got started on her next piece as well. She told me that not only was it the fastest that she had ever completed a large painting, but that it was probably her best work so far. Because she had a specific place she was trying to get to, she stopped second-guessing her own work and just moved forward. This is a great place to be in as an artist.

Please note that I'm not saying that you shouldn't think deeply about your art. You absolutely should. But in this case, it worked out well for Kim to be focused on finishing, and she never would have known that if she didn't set a goal to push herself. Many people create their best work under pressure.

Concurrently, we also began looking at the components of how she was promoting her work. We looked at how she was using social media, her mailing list, and her relationships with local galleries. It turns out that Kim had previously worked as a sales agent at a local gallery and knew a lot of people in the local art scene. We decided to focus some time on renewing those relationships. We agreed that it made sense to dedicate some time to finding a place to show her work. She previously wasn't doing this because she didn't feel like she had enough of a series to do a show, but with a couple of weeks of her newly structured painting schedule under her belt, she felt like she had a pretty good idea of when she would be able to complete the new series.

By picking a date to have a new show, she was able to give herself

even more focus on her marketing and her art. We put together some proposals that were specific to her art for the kind of show she'd like to have, and she started calling her local contacts and letting them know she had a new series that was underway, when it would be done, and why they should show her work at their venue.

Within a month, she had interest from two different locations, and a potential solo show in the works. She also had an opportunity to hang some of her already existing works, with her name and contact info, in a local restaurant that was opening with a huge party.

This may seem like magic, but it's really just the result of hard work on both sides of her art business. Here's an example of the kind of schedule that we put together for her. This schedule is general, and obviously it will vary from week to week, but it gives you a good idea how to set up your week. Some things to note about this schedule:

Dedicated writing time. Artists often complain to me that they are terrible writers. Learning to write is just like learning to paint: the more you do it, the better you'll be at it. I'm going to be your annoying writing teacher again and remind you to make time for writ-

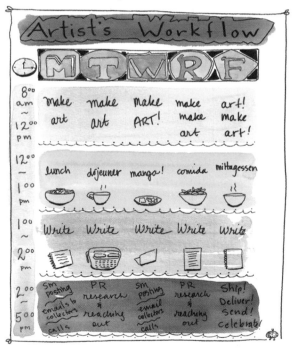

ing about your art. Blog posts, social media posts, and articles for major publications will bring interest to your work and help people understand enough about your art to be interested in what you do as an artist. In addition, you have the opportunity to participate in the broader conversation happening about topics related to your interests.

Dedicated PR time. For an artist just starting out, you need this time more than anything else in your marketing. You need to be talking to journalists, critics, and other people who can spread the word about your work. It's a lot of effort in the beginning or when you have a show coming up. But that work will lead to more people seeing your stuff.

Following the suggestions from chapter 8—to promote your work to media organizations and blogs every week—will help you grow your audience. I've seen artists have steady success by devoting as little as five hours a week to their media promotions over the course of three months.

Not asking for the sale

So many artists I know are afraid to talk about their art, let alone ask people for sales—but at the most fundamental level, not asking for the sale is a guarantee that you won't get it. Rarely does someone walk into a gallery, see a piece of art for the first time, and whip out their credit card or checkbook. It just doesn't happen. People want to be asked. They want to be pursued. They want to be wooed. People are often afraid to buy something.

There are various ways you can ask for the sale. Here are a handful:

Would you like to take this home today?

Have I answered all of your questions?

Which credit card would you like to put that on?

Would you prefer check or credit card?

If that all sounds good, we just need to get this commission agreement signed.

Are you ready to make a decision on this right now?

Which day would you like to stop by and pick up the painting?

Would you be interested in renting it for a month to see how it fits in your space?

Note that many of these questions are what we call assumptive closes. They assume the buyer wants to buy the art. It's okay to ask it this way. If the person doesn't want it, they'll tell you they don't want it. And when you ask for the sale, the worst thing that usually happens is they say no.

But how do you do this online? In chapter 6, we talked about e-commerce. Those Buy Now and Add to Cart buttons are the primary way you ask for the sale on your website. If for some reason you're not comfortable with e-commerce on your site, then be sure to have very clear buying instructions with each piece that you list on your site. Something like, "To purchase this piece, contact me at me@mydomain.com."

Consider also that you must ask for the sale when you are putting your blog posts and social media posts together. In your blog posts, you should let people know that your work is available for sale. Some bloggers choose to do this by inserting a link in the footer of each blog post. It's even more effective to link to the sales page of the work you're discussing within the body of the blog post.

The same rule applies to social media. I see a lot of artists sharing

their work in progress shots, but never saying something like, "This piece is available for purchase at [link]."

Here's something that few artists know, but all professional sales people know: in order to get a yes, you must go through a lot of no. There's no set number, but it looks something like this on the Web:

Average conversion rates for the sales process online:

15,000 people see your work
500 join your mailing list
200 people open your mailings
20 consider your offer
1 person buys something

You can make the biggest difference in the formula above by paying attention to that top number: the number of people who see your work. If you're just aiming at everyone in the world, you're going to have to go through a lot more people to make a sale. But if you're aiming at the right people—the people who resonate with your message and your Uniquity—then that starts to look something like this:

1,500 people see your work
500 join your mailing list
200 people open your mailings
40 consider your offer
5 people buy something

You might even be able to make your funnel perform even better. It just depends on how well you select the initial group of people to which you market.

I get the pricing question *a lot*. Almost every day. A few years ago, Melissa Dinwiddie wrote a phenomenal post on The Abundant Artist blog about how she handles pricing, and I'll just share that post here.

"HELP, HOW DO I PRICE MY PAINTINGS?"

A few months ago I started sharing snapshots of works in progress on social media. Not long afterwards, someone I know on Facebook asked if my work was for sale, because she wanted to buy a particular piece I was working on.

It gets better: turns out she was interested not just in purchasing the canvas-in-process; she also wanted me to create a second, "sister canvas" to go with it.

Just from posting my process pics on Facebook, I had a buyer for not one, but two paintings! Great!

The only problem? Now I was going to have to come up with a price . . . Groan!

I am convinced that pricing is always the hardest thing I do as an artist. How the heck do we decide what to charge? Pricing just feels like a big, black void, and one with a lot of pressure: charge too much, and they'll run away; charge too little, and you're shooting yourself in the foot.

Ultimately, this spontaneous Facebook commission made me determined to set an entire pricing structure for my work, rather than just grabbing a number out of the air every time I create a new piece. Here are some of the "ground rules" I followed, and some tips that I hope will help you confidently set pricing for your own art.

PRICING GROUND RULES FOR PAINTERS

1) Remember: your pricing gets to change.

If, like my story above, you've got a client waiting to hear back about a price, know that as you become more established, you'll be able to command higher prices. You may even raise your prices on your very next sale.

In other words, whatever you charge this one client is not set in stone, so don't stress too much about it. Keep in mind, though, that it's always a better business move to raise your prices than to lower them, so leave yourself some room for growth.

2) Never undercharge.

That said, leaving no room for growth is not actually most artists' problem—most of us have the opposite issue: charging too little. Once I brought art to be juried into a show, and was horrified that one of my fellow artists was charging less for her work than it had cost her to frame it!

Needless to say, this is a big no-no. Always make sure your pricing covers your actual costs (canvas, paint, framing, shipping if applicable—unless you're going to charge a separate, additional amount for shipping/packaging).

You also want to take into consideration how much time you put into creating your work. Emerging artists may not be able to command high enough prices to pay themselves fantastically for their actual time spent, but that's definitely the goal for the long term!

If you're lucky enough to work fast and loose, you can get away with charging less, because each piece just doesn't take long to produce. How-

ever, if your style is very detail-oriented and meticulous, what another artist could sell happily for $500 might mean you'd be earning pennies per hour, which is not sustainable. Your choice, then, is to grit your teeth and charge a lot more, and/or to figure out how to offer less-expensive work (smaller and/or looser originals, prints, etc.).

Not sure if you're undercharging? I have a practically foolproof gauge: resentment. If I notice myself feeling resentment about a sale, it's a good bet I need to raise my price!

On the other hand, if my prices don't make me feel at least a little uncomfortable that I'm charging too much, I'm probably undercharging!

Your mileage may vary with this: start to pay attention to whether you tend to undervalue or overvalue your work, and adjust accordingly.

3) Be clear and consistent.

Of course your goal is to be paid well for your time, but the truth is, some of your pieces probably take a lot longer to create than others.

You know how much work went into each piece, but customers don't know (and don't usually care) how long it took you to create a piece. Charging by the hour is likely to result in a lot of confusion as potential customers look at two pieces of the same size and wonder why piece A is so much more expensive than piece B.

Customers who are confused do not buy, which is why I'm a believer in clarity and consistency.

Size-based pricing

If you're a painter, one way to ensure you're clear and consistent is by using size-based pricing—either by the square inch (H × W) or by the linear inch (H + W). This makes your pricing easy for potential clients to understand, and it prevents you from charging more for pieces you're particularly fond of, which makes your pricing seem random and confusing (and remember, customers who are confused do not buy).

With size-based pricing, you simply need to determine your current multiplier (the number you multiply by the canvas size) in order to immediately know the price for any given piece (okay, possibly with the help of a calculator . . .).

If you create in a lot of different sizes, you may find linear-inch pricing more sensible than square-inch pricing. Why? When you charge by the square inch, the price difference between a small painting and a larger one can become astronomical.

Here, for example, is square-inch pricing, using a multiplier of 2.5 (i.e., $2.50 per square inch):

4×4 inches = 16 square inches × 2.5 = $40
8×8 inches = 64 square inches × 2.5 = $160
16×16 inches = 256 square inches × 2.5 = $640
24×24 inches = 576 square inches × 2.5 = $1,440
32×32 inches = 1,024 square inches × 2.5 = $2,560

I don't know about you, but $40 seems an awfully small price for a painting by someone who commands $2,560 for a 32×32 canvas.

Here are the same canvas sizes using linear-inch pricing, using a multiplier of 20 (i.e., $20.00 per linear inch). As you can see, the difference in price feels a lot less out-of-whack:

4+4 inches = 8 linear inches × 20 = $160
8+8 inches = 16 linear inches × 20 = $320
16+16 inches = 32 linear inches × 20 = $640
24+24 inches = 48 linear inches × 20 = $960
32+32 inches = 64 linear inches × 20 = $1,280

Neither of these pricing methods is right or wrong, but once you determine your method and your multiplier, charging by size can be a very helpful way to eliminate the guesswork, and make you feel confident about your pricing.

Different pricing for different media?

One possible modifier to your size-based pricing structure is the media you paint with. If you only paint watercolors, or only paint oils, there's no problem, but if you paint both on canvas and on paper, as I do, it gets a little tricky.

For whatever reason, paintings on paper tend to sell for less than paintings on canvas—even though they require framing, which is an added expense. In my case, if I were to pay to have a piece framed, my costs become much higher for a work on paper than for a canvas painting! What's an artist to do?

I don't have a final answer to this question, except to refer you to the next ground rule.

4) Do your research.

It can be useful to look around at what other artists are charging for their work: artists in your local area, and especially artists at a similar stage in their careers.

What are people charging for framed works on paper? For unframed works on paper? For stretched canvases?

The challenge here, though, is that what other people charge is likely to be all over the map. So when you do your research, be sure to take into consideration how you want to brand yourself. Do you pride yourself on making "art for everyone," at "everyman" prices? Or do you want to make your mark as a high-end, premium-pricing artist?

When artist Matt LeBlanc was deciding what to price, he looked at what kinds of art were available in his area and noticed the low end and high end of the market were rather saturated. The midrange, though, didn't have a lot of competition, so that's the price range he decided to set on his paintings—at the time of this writing, Matt has work for sale from $50 to $900.

This kind of research worked well for Matt: he went from selling no art, to being featured on HGTV, and being one of the hottest-selling artists in his area.

5) State your price, then shut up.

My most expensive moment as an artist was several years ago, when a couple flew out to California from Philadelphia to meet with me about commissioning a ketubah for their anniversary.

I'd already told them my price range, which at the time was something like from $1,500 to $5,000 (mistake no. 1: never put an upper limit on your

pricing!), and when they told me what they were looking for, I realized it was going to be one of the most time-intensive pieces I'd ever made.

In other words, this was a top-of-the pricing-scale commission.

However, I'd never yet commanded $5,000 for a piece, and I was afraid this number, which felt so big to me, would scare them off! So when it came time to give them an estimate, I hemmed and hawed, and said something like, "Well, what you're looking for is at the top of my price range."

Then, instead of keeping my mouth shut and seeing how they responded, I stupidly barreled ahead to say, "But if five thousand dollars is too much for your budget, I can always scale back the design to make it less expensive."

D'oh!

The husband said, "Three thousand dollars, four thousand dollars, five thousand dollars—it's all the same to me. But I'm a middle-of-the-road kind of guy, so let's go with the middle price—four thousand dollars."

Yep—because I couldn't just state my price and shut up, I lost a thousand dollars in a heartbeat. (And "scaling back the design" is a myth. It never happens!) Lesson learned.

This one is important, so I'll say it again: state your price, then shut up. Period. Do not explain, do not apologize.

(I've done that too—gotten defensive about my pricing—and oh, the pain! Now I've learned to say, "If you like my work, this is the price. If you don't want to pay that, you don't have to buy it.")

If you're sending an e-mail to a potential customer, "state your price and shut up" might look something like:

"For this painting, the price is X dollars [plus shipping/packaging, if you're charging for shipping separately]."

Or

"I charge Y dollars per linear inch, and this painting is twenty-four

by thirty inches, which is fifty-four linear inches, so the price is (Y × fifty-four) dollars."

Then:

"If you'd like to purchase it, just let me know and I'll send you a link to a payment page where you can pay either with a credit card or your PayPal account [or whatever payment method you use]. Once I receive your payment and shipping address, I'll ship your painting to you via [shipping service]."

Be sure to indicate when you'll ship: A day? A week? Does the painting need to cure first? Does it need to be varnished first?

SUMMING UP

The really challenging thing about pricing is that there are no hard-and-fast rules. Everything depends on you, your work, where you live, where you are in your career—there are so many variables it can drive us nutty!

The tips I've shared here have helped me get more confident with my own pricing. I won't lie to you, pricing my work is still really, really hard, but hopefully these ground rules will help light your path as you negotiate this trickiest of areas for artists.

NOT ASSESSING YOUR RESULTS

Once you've set some structure around your time and you have an idea of how to be effective with your marketing, it's time to start measuring what you're doing to see if you're getting the results you want.

One of the great things about the Web is that almost everything you do is measurable. One of the bad things is that almost everything you do

is measurable. It's hard to know what to pay attention to, and when it doesn't matter.

As a budding "artpreneur" here are the things that actually matter, in order of importance:

- Sales
- Leads
- Everything else

By keeping your measurement simple, you can ignore all the other data and avoid feeling overwhelmed. Every time some new Web tool or toy comes along, you should ask yourself, "How does this help me make more sales?" If there's no connection, then ignore it. I see far too many artists waste their time trying to learn every Web tool and toy, every trick, hack, and tactic. If you focus on just what's in this book, you will make sales. Once you start making sales, you can hire people to handle the other stuff for you.

Primary to sales is tracking leads. Who are your potential customers? Where are they in the sales process? How quickly do they move through the buying process? How many times, on average, does someone look at your work before they buy? Where do your most important customers come from?

WEB TRACKING TOOLS

You can use tracking tools to measure how many people come to your website, which pages they visit, and how much time they spend on each page. Google Analytics is a free tool that will do everything you need,

plus a whole lot more. Just go to google.com/analytics to sign up. The tool integrates with nearly every website platform in the world with just a few clicks of a button, and integrates with WordPress with the Google Analyticator plug-in.

Web tracking and analytics tools are an absolute requirement for all websites, and Google Analytics is the most extensive free tool there is—far better than any of the packages that come with the websites you might use.

Google Analytics is a massive tool, and there is a lot of data in there. I recommend you look at the following data once a week:

- Number of unique visitors (found under Behavior > Overview)—the raw number of people on your site.
- Source of visits (found under Acquisition > Overview)—for a healthy artist website, this should break down into about 20 percent search engine traffic, 25 percent direct/e-mail traffic, 30 percent referral traffic (other bloggers and websites linking to your site), and 25 percent social media traffic.
- Time on site (found under Acquisition > Overview > Avg. Session Duration)—how much time the average person spends on your website. If it's less than one minute, then your site is likely not exciting enough, not user-friendly, or you are attracting the wrong website visitors.
- Top Pages (found under Behavior > Site Content > All Pages)— tells you which pages on your site are the most popular. You'll usually notice that it's your blog posts, home page, and perhaps your shop home page. Once you know this, you'll know which marketing is the most effective and what kinds of things you can try to replicate.

E-MAIL MANAGEMENT SERVICES (EMS)

We discussed EMS in chapter 7. You can use e-mail management services to measure how many people open your e-mails and click the links in them. Along with your weekly Web analytics check-ins, you'll want to check your open rates to make sure people are reading your e-mails, and to see how many leads you've added to your list.

It's hard to get to that first one hundred e-mail subscribers. I know a lot of artists who spend more than a year before they get there. Don't beat yourself up about it. Set a goal to grow your list by three to five people each week until you get to a hundred, then up your goal.

Keep in mind that the size of your list doesn't matter as much as the number of qualified leads that you're accumulating. I know an artist with less than five hundred people on her list who makes $50,000 per year. Track where your e-mail opt-ins are coming from, and who is buying. This will give you the best information on where to spend your marketing time and dollars.

URL SHORTENERS

A lot of times social media sharing makes tracking how many clicks you got difficult. In addition, your blog post with the URL johnsmithartist .com/really-long-blog-post-url is difficult to fit into a Twitter post.

That's why people use services like Bitly.com. In addition to shortening your long blog post URL to something like bit.ly/jsmith, you can use URL-shortening services to measure how many people click those links. Then you'll know how well your blog posts are doing in various social

media. In addition, with a little technical knowledge, you can add campaign tracking tags that will allow you to track those clicks in your Web analytics package, so you can see which links are creating sales on your website.

TAKE THE LEAP AND MAKE YOUR OWN MARKETING COMPOSITION

I can teach you everything you need to know to build your own successful art business. But I can't run it for you. I have taught you principles and shown you case studies. Hopefully you're starting to see what the structure of a successful art business looks like.

Now it's time for you to start envisioning your own success and filling in the colors.

It's time to go do the journaling, the website setup, the writing of blog posts, and the social media interaction. It's time to join the ongoing cocktail party. It's time to go be yourself in the world, and invite others to see what you do.

Once you've started testing the ideas in this book, you can see how people respond to what you do. Then you can use your own ideas to make it even better. Since you are the creative genius, your ideas on top of solid foundational principles are what will set your marketing apart from all the other artists.

As I've shown you through the case studies in this book, it's possible to make a great living as an artist. It's not easy, but starting a small business is difficult no matter what industry you're in.

You can do it. You don't need the gatekeepers. You can build a life that

is full of not just financial abundance, but also creative fulfillment, professional accomplishment, and the freedom to make the decisions that matter to you and your family. You can make an impact on the world, in the lives of individuals touched by your art and your ideas. You can live that creative life on your own terms.

ACKNOWLEDGMENTS

When I started The Abundant Artist, I was just hoping to share with my immediate friends what I was learning about how to be a successful artist. I'm so grateful that enough artists have found my work helpful enough to warrant this book and the attention The Abundant Artist has received.

Big thanks to the following people: Lissie Huff for being my eternal companion and biggest cheerleader. Cynthia Morris for doing an excellent job transferring my words and thoughts into visual representations. David Fugate for believing enough in this book to see it through the refinement of the pitch, and then being an excellent agent. Rebecca Hunt for her cheerleading, editorial notes, and reminders to get stuff done. Nathan Barry and Gina Rau for pushing me to actually get this written and for introducing me to David. Jason Van Orden for being my business mentor and dear friend. We'll always have Paris.

I talk about a lot of artists in this book, and I'm grateful to them for sharing their stories. As I've told many people, I am someone who is deeply interested in making sure that art continues to happen. In order for that to happen, artists need to thrive. Without these artists shar-

ing their stories with me, the things I teach wouldn't resonate nearly as much. A special thanks to those artists who've made it their mission to make sure that something like The Abundant Artist succeeds: Gwenn Seemel, Matt LeBlanc, and Melissa Dinwiddie.

I'm sure I missed someone important. If that someone is you, I'm sorry. I'll buy you a cupcake and you can tell me all about it.

ABOUT THE AUTHOR

CORY HUFF helps artists dispel the myth of the starving artist by teaching them how to sell their art online. He is also an actor, director, storyteller, and photographer. He lives in Portland, Oregon, with his wife and their two perfect cats. You can read more of his work at theabundantartist.com.